Chris Ofili

Tate Publishing

Chris Ofili

Edited by
Judith Nesbitt

With contributions from
Okwui Enwezor
Ekow Eshun
Helen Little and
Attillah Springer

First published 2010 by order of the Tate Trustees
by Tate Publishing, a division of Tate Enterprises Ltd,
Millbank, London SW1P 4RG
www.tate.org.uk/publishing

on the occasion of the exhibition
Chris Ofili
Tate Britain 27 January – 16 May 2010

Supported by

LOUIS VUITTON

with additional support from The Chris Ofili Exhibition Supporters Group

A catalogue record for this book is available from the British Library

ISBN 978 1 85437 881 1 (hbk)
ISBN 978 1 85437 870 5 (pbk)

Distributed in the United States and Canada
by Harry N. Abrams, Inc., New York

Library of Congress Control Number: 2009941716 (hb only)

Designed by Why Not Associates
Printed in Belgium by Die Keure
Printed on sustainably sourced, certified paper

Front cover: *Blossom* 1997 (detail, p.35)
pp.2–3: *Mono Turquesa*, from *The Upper Room* 1999–2002 (detail, p.88)
pp.164–5: *Dance in Shadow* 2008–9 (detail, p.141)

Measurements of artworks are given in centimetres,
height before width.
Where support is given as 'canvas' it is made of cotton.
Linen canvases are credited as 'linen'.

Contents

Foreword

In the fifteen or so years since he left the Royal College, and especially since he won the Turner Prize in 1998, Chris Ofili has covered a lot of ground. Restless, self-questioning and ambitious for the voice of painting in contemporary culture, he has consistently set himself new challenges when he might more comfortably have rested on his laurels.

Electric, dazzling images packed with the sexual and physical references of hip-hop culture have given way to mythical and more elegiac subjects which grow from his own personal experience of love, and the warmth and colour of the Caribbean. However, Ofili is never satisfied with the immediate narrative alone. The form and content of his work bring together an unusually wide range of sources from the art of the past, his contemporaries and popular culture. Some of the most influential of these, such as William Blake's watercolours, drawings and words, share Ofili's ability to create beautiful objects that also look at the darker aspects of contemporary society and draw our attention to the social injustice as well as beauty in the modern world.

Great art often emerges when cultures cross boundaries or migration brings ideas and values into sharp conflict. Ofili, who grew up in Manchester to Nigerian parents, has continuously drawn on a hybrid contemporary culture and by taking himself to Trinidad he has continued to expose himself and his language to new influences. This exhibition at Tate Britain is the most thorough survey of Ofili's work to date and aims to open up new understanding of his ambitious approach to painting. Brought together, these works show how the artist's formal inventiveness and experimentation have developed into a distinctive iconography, fusing different cultures with spirituality, myth and the natural world.

Tate is indebted to the institutions and individuals who have generously lent their works and to the Museums Libraries and Archives Council for arranging indemnity cover on behalf of Her Majesty's Government. We are most grateful to The Chris Ofili Exhibition Supporters Group whose collective support has been critical to the successful realisation of this project. Our heartfelt thanks to Mr and Mrs Ben Brown; Carolyn and Leslie Goldbart; Hollick Family Charitable Trust; Dakis and Lietta Joannou; The Nyda and Oliver Prenn Foundation, in memory of Nyda Prenn; Helen and Ken Rowe; Tishman Speyer; David and Emma Verey and those donors who wish to remain anonymous. I am also grateful for the support of Louis Vuitton and Guaranty Trust Bank.

The exhibition has been conceived and realised with extraordinary care in a close collaboration between the artist and Judith Nesbitt, Chief Curator, Tate Britain, ably assisted by Helen Little. A wider project team brought the show together with a shared vision and enthusiasm. Our greatest thanks are due to Chris Ofili for his imaginative involvement in every aspect of the exhibition, and for his risk-taking ambition, so evidently rewarded in this luminous body of work.

Nicholas Serota
Director, Tate

Curator's acknowledgements

I wish to thank Chris Ofili for his wholehearted commitment to making this exhibition. His total dedication to every aspect of the project brought it to life with the same verve and passion that characterise his art. His gracious, collaborative spirit and patient attention to detail have inspired the entire project team.

We owe sincerest thanks to the Afroco team for their indefatigable efforts on so many fronts. Mel Francis, Vicki Thornton and Bella Vernon responded to our many requests with exemplary professionalism and friendly support. Ben Marley in particular brought his knowledge and huge dedication to the production of the catalogue. The entire Afroco team have been wonderful collaborators.

The artist's galleries have provided invaluable assistance at every stage. We thank especially Victoria Miro, Erin Manns and Kathy Stephenson at Victoria Miro Gallery, London; David Zwirner, Angela Choon, Stephanie Daniel, Silva Skenderi, Joel Fennell, Tim Eastman, Julia Joern and Liz DeMase at David Zwirner, New York; Nicole Hackert, Bruno Brunnet and Adriana Markovic at Contemporary Fine Arts, Berlin; and Gavin Brown's enterprise, New York. In helping us locate individual loans we are most grateful for the assistance of Francis Outred and Dina Amina at Christies and Oliver Barker and Alexander Branczik at Sotheby's.

Ekow Eshun, Okwui Enwezor and Attillah Springer have made creative and insightful contributions to the catalogue. Further content was researched and compiled by Helen Little, Krzysztof Cieszkowski and Fiona Baker. The whole publication was expertly overseen by Rebecca Fortey and her colleagues at Tate Publishing, Roanne Marner and Deborah Metherell, in a fruitful collaboration with Andy Altmann and Terry Stephens at Why Not Associates who conceived of this elegant design.

At Tate Britain, I would particularly like to thank Helen Little, Assistant Curator, for the focus and energy she has brought to the project from beginning to end. Many other members of Tate staff have helped deliver key aspects of the exhibition: Kirstie Beaven, Helen Beeckmans, Jane Burton, Louise Butler, Gillian Buttimer, Indie Choudhury, Hanne Dahl, Mark Edwards, Paul Goodwin, Juleigh Gordon-Orr, Duncan Holden, Mikei Hall and his team, Carolyn Kerr, Gina Koutsika, Billie Lindsay, Kirsteen McSwein, Celeste Menich; Mark Miller; Marilena Reina, Alyson Rolington, Andy Shiel, Patricia Smithen, Silaja Suntharalingam, Alice Teng, Piers Townshend, Natasha Walker, Piers Warner and Andrew Wilson. Finally, to Stephen Deuchar and Nicholas Serota, my thanks for their support and guidance throughout.

Judith Nesbitt
Chief Curator, Tate Britain

Beginnings
Judith Nesbitt

There are so many ways to begin. Across two decades of Chris Ofili's life as an artist, there have been many beginnings. Many clearings and fresh starts. Sometimes the journey through his work seems cyclical. Trinidad, where he has lived since 2005, came into his life through an invitation from the same agency (Triangle Arts Trust) that led him to Zimbabwe in 1992. Both places were points of embarkation. Born in Manchester in 1968, to Nigerian parents who had moved there from Lagos in 1965, Ofili has learnt to enjoy the momentum that comes with new beginnings, and has sometimes actively sought them. Being in Trinidad is 'like starting again, entirely'.[1]

Artists do not set out with an eye on the horizon line, working towards museum shows in which the uneven, uncertain labour of days and years spent in the studio is neatly assembled, scrutinised, and assessed. They usually make their works – paintings, for example – one at a time. Sometimes one painting is affiliated to others within a group, but each painting has its time and place. A survey show is therefore a strange reunion – these pictures did not all grow up together. Many have never even met. It is their relationship to the artist that binds them together. The responses they elicit from one another are unpredictable – even, or especially, for the artist. The work is revealed afresh. It begins again.

'Things began in '87 '88 '89'
Sometimes it's the swerve that proves decisive. On leaving school, Chris Ofili planned to study furniture design at Loughborough University, but was told he had first to take a Fine Art foundation course. With teenage impatience, he thought this would be a waste of time, but in autumn 1987 enrolled at Tameside College of Technology in Ashton-under-Lyne, a Lancastrian town within the bulging urban belt of Greater Manchester. There, amidst routine experimentation in various media, Chris Ofili discovered painting. He had never really painted before, had no idea what it was to be an artist, and had never been to a museum. 'I remember picking up a brush, feeling a little clumsy, but it was quite exciting because it was non-judgemental. That was it for me.'[2] Six months into his foundation year, he opted to specialise in painting, in Bill Clarke's class. More than anything else that followed, this first year of his art education was transformational. Ofili realised painting was something for him – a direction, an end in itself; he saw it could be a way of being himself. He remembers taking the train to London in spring 1988 to see the *Hans Hofmann: Late Paintings* show at the Tate Gallery, and again in the summer to see *Late Picasso* there. Though making art and being an artist were not ideas he had grown up with, he could see that painting was a great thing to do with his life. At the very least, going to art school would get him to London. He figured that with a bursary, he had enough for accommodation and materials.

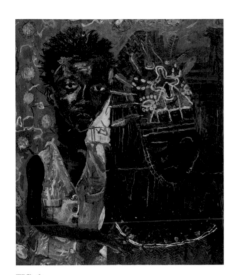

FIG. 1
The Queen and I 1989
Oil on canvas 127 x 101.5

1.
Conversation with the author, Port of Spain, June 2009.

2.
Quoted in Kodwo Eshun, 'An Ofili Big Adventure', *Arena*, October 1998, p.140.

3.
Peter Doig's foreword in *Chris Ofili*, New York 2009, p.7.

4.
'Thelma Golden & Chris Ofili: Conversation', in ibid., pp.237–8.

The painting course at Chelsea School of Art was recommended to him by Bill Clarke, his foundation year teacher. It was run by David Hepher, a friend of Clarke's since student years at the Slade. At Chelsea, with 'nobody telling you what to do', he took the licence to experiment. He thrived amid the mix of permissiveness and robust debate, sharing a studio with Steve Claydon and Neal Tait (who remain artist friends; they recently made a trip to see Italian frescoes for the first time). Peter Doig (another friendship begun at this time) was then an MA student at Chelsea who had to present his work to Ofili's year group; he remembers Chelsea as a fertile ground for painters: 'There was a great enthusiasm for the material in some quarters and a distrust of it in others; this made the debate strong and positions were taken.'[3] Ofili's paintings were based on observation: representations of himself and others, in front of a mirror, behind an easel, looking out, watchful. The figures have a faltering air, like actors on stage without a script. Expressionistic in style, indebted to Basquiat and Baselitz, Ofili's paintings did not go unnoticed. To viewers versed in cultural theories of representation and the identity politics of so much of the art of the 1980s, Ofili's self-portraits read as statements about visuality and blackness. Such theorisation dominated art practice and criticism in the late 1980s, but Ofili's starting point was his own experience, personal and political: 'Being a young black male in an art school that wasn't full of young black males gave me an intense awareness of the differences between what I would represent and what others might represent … There was no-one else painting black people or black life, so to speak, within my peer group at art school.'[4] His response was not programmatic or polemical, but quizzical. In making himself the subject of his work, he began his own enquiry into what painting could be, and do. And it had something to do with him.

Ofili's first forays into exhibiting proved fruitful. At the end of his first year at Chelsea he was selected for the 1989 *Whitworth Young Contemporaries* in Manchester and won a prize for *The Queen and I*. Another painting, *Two Ways of Looking at It*, was selected for the 1990 BP Portrait Award at the National Portrait Gallery. He had his first solo show *Paintings and Drawings* at the Kepler Gallery in Brixton, South London, in 1991 (long since closed down) and in the same year started an MA Painting course at the Royal College of Art. After the experimental culture of his Chelsea BA, the more focused approach to painting at the RCA was an abrupt shift. Perhaps in a bid to unsettle himself still more, he took an opportunity to study abroad.

Zimbabwe and Berlin

In 1992 Ofili secured travel funds from the British Council to attend the Pachipamwe International Artists' Workshop in Zimbabwe, organised by Triangle Art Trust. For two weeks he and the other visiting artists worked alongside Zimbabwean artists in a school building serving as a studio. The following four weeks were spent exploring. He went on horseback safari, getting up close to herds of giraffe. The tracker would look at the animal dung to see which animals were closest, judging by the freshness of the dung. Ofili wanted to see elephants, but did not: a drought that year meant elephants did not congregate in their usual drinking spots. Struck by the incongruity between his formal painting aesthetic (which had by now veered towards a fluid modernist abstraction) and the environment in which he was working, he took some of the elephant and cow dung in its dried-out state, and stuck it onto a painting, just to see what would happen. 'It was a crass way of bringing the landscape onto the painting',[5] he later recalled, but it was a productive collision. His art school knowledge of the readymade gave him the 'get-out clause' should he need one. The inherent ugliness of the material suggested to him that he needed to 'tune up' the paintings, so that the viewer would be torn between its decorative attraction and the repulsion of excreta. A visit to the prehistoric San cave paintings in the Matobo Hills also made a deep impression on Ofili. He noticed that besides the archetypal representations of figures and beasts was a wall marked only with dots. He asked why this wall was different to the rest, and the answer pleased him. The supposition was that this might have been painted by someone who did not go on the hunt but stayed behind and worked in the cave, perhaps in a meditative state, in which music may have played a part.

Ofili returned from Zimbabwe with dung packed in his luggage. Keen to spend his time away from the Royal College itself, he was one of the first to apply for an exchange scholarship to art school in Berlin. Though he arrived knowing little about Berlin, he quickly sensed the liberation in a city still raw and opening up after the fall of the Wall. Newly arrived creative entrepreneurs, eastern Europeans and property speculators were setting up in the widely and cheaply available space. Ofili remembers the WMF basement nightclub, entered through a freight container. Hip-hop was a powerful new arrival from the US, with Snoop Dogg and The Notorious B.I.G. hitting the scene. There was more art to be discovered there too; Ofili recalls standing for hours looking at Sigmar Polke drawings, and a trip to Kassel *documenta* where he saw gas chamber paintings by Luc Tuymans, vaporous linear abstractions by Brice Marden, David Hammons's fountain-head piece with Afro hair and Charles Ray's *Charlie Charlie Charlie*, amongst many others. Seeing these artists at the top of their game made him realise the challenge was not about competing to better this, it was about doing his own thing. He had to be able to sustain his imagination through painting. Ofili returned from his year in Berlin and completed his degree.

5.
'Decorative Beauty was a Taboo Thing', interview with Mario Spinello, *Brilliant! New Art from London*, exh. cat., Walker Art Center, Minneapolis 1995, p.67.

6.
Ibid., p.67.

7.
Ibid., p.67.

8.
Ibid., p.67.

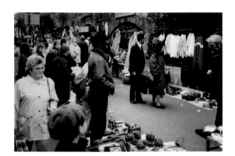

FIG. 2
Shit Sale (London) 1993

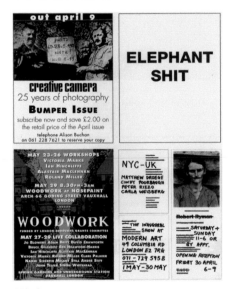

FIG. 3
Frieze Magazine Advertisement 1993

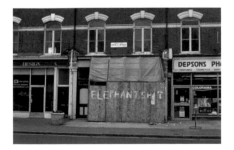

FIG. 4
Elephant Shit (King's Road, Chelsea, London) 1993
Emulsion paint on street hoarding

Elephant Shit

Whilst in Berlin, Ofili continued his experimentation with elephant dung. Inspired by David Hammons's *Bliz-aard Ball Sale* of 1983, in which snowballs were offered for sale to the public, he 'sampled it' by staging *Shit Sale* on Strasse 17 Juni, Berlin. With dung balls placed unceremoniously on a thin piece of fabric on the pavement, wedged between traders selling rock albums on one side and cheap jewellery on the other, the artist occupied his pitch. He repeated the performance at Brick Lane market in London's East End. The eclectic spectacle of the market appealed to him: 'You can buy everything there, from stolen bicycles and fruits and vegetables to dirty videotapes, stolen hi-fi equipment, phones, bags, clothes … People go there in their leisure time to see something interesting. Not necessarily to buy, just to look and to feel they're experiencing culture.'[6] The dung balls were not for sale; they were objects in a performance of responses spontaneously triggered between him and the market visitors. 'I wanted to have something in between me and them that I was interested in, and see what people's response would be … People in Germany thought I was some kind of witch doctor. In England people thought I was pulling the wool over their eyes, that it was a candid camera situation. Somebody was going to pop out and they'd be caught.'[7]

In May 1993, while still a student, Ofili took out a quarter page advert in *frieze* magazine (still in its early months and prepared to give him a good price for the space). It simply stated: ELEPHANT SHIT. Rather than advertising a show or an artist, Ofili used the space to tease out some responses to the material he was working with before he had ever showed any paintings with dung. Ofili's action opened up the space for him – operating, in his words, as a 'stop gap'. For several months, ELEPHANT SHIT stickers appeared around the city: stuck to posters in the London Underground, above ground on Ofili's route from Fulham to the Royal College, in clubs, exhibitions, and on cars. The words also appeared as graffiti painted on shop hoardings on the Kings Road. Dung (now procured from Whipsnade Zoo) was rolled between Rizla cigarette papers to form the works *Shit Joint*; rolled into balls, placed in a paper grocery bag and covered in sugar-like resin to form *Bag of Shit* (in homage to Robert Gober's *Bag of Donuts* of 1989). Later Ofili made three dung sculptures called *Shithead*, all decorated with his own short dreadlocks and one of them with a purloined set of milk teeth (p.23). Appropriating the stereotype of a grinning, disembodied African head, Ofili's fetish-like object arose directly from the two-way confrontations between him and his audience in *Shit Sale*. 'They would approach the crowd, and when they finally got through they'd look at the shit. Then they'd look at me. They'd look at the shit. They'd look at me. And then it would get to them. So it was a cycle of looking in which they put me together with the shit and created an image from those two.'[8]

To Boldly Go

There was encouragement in 1993 when Stuart Morgan (who had come across his work as a visiting critic at the RCA) invited Ofili and two other young artists to participate in his guest-curated show, *To Boldly Go*, at Cubitt Street Gallery, the artists' studio space and gallery near Kings Cross. Morgan's reputation as an influential critic and curator guaranteed attention to his choice of young artists. The press release upped the ante:

> Curators should be shot, they say. Artists could do better themselves. Weary of cheap abuse, an over-sensitive critic decides to get his own back. First he picks up the telephone just long enough to invite three young painters to show at Cubitt Street. Instead of visiting their studios, he gives them directions to the space and the time to arrive. There they find paint and primed canvases. From that moment, they will have two weeks to make large works, which will be hung an hour before the opening. Their only instructions will be to go for broke. Can punk curating produce masterpieces? All will be revealed in *To Boldly Go*.[9]

Rising to the challenge, Ofili showed three paintings, all propped up on dung balls rather than hung on the wall: *Whooley, Ongley and Cattle* (since destroyed), *Open* and *Painting with Shit on it* (detail opposite). The latter's title said it all; swirls of orange paint applied in myriad individual dots, floating blue rectangles looking for somewhere to settle – all these decorative elements were stopped in their tracks by the coagulating dribbles of resin seeping from the splat of dung and straw. Chris Ofili had made an entrance.

Ofili likens the experience of leaving the protected environment of art school to coming out of jail – 'you don't exist, unless you start to build yourself up, and start to work'.[10] He worked in a regimented and focused way, in an attempt to gain momentum. Armed with enough confidence and determination to sustain him, not sharing an art school studio anymore, he relished time on his own, with no one coming in and out of the room all the time. He wanted no one else's expectations but his own. His warm and wide studio was in a shared building right on the Thames, on the Fulham/Chelsea border. Paying rent, however cheap, for space in which to paint, Ofili realised that 'if I was going to hold onto these things, I'd better make things I really, really liked'.[11] He resolved to work from his own experience, as something known; the making of the painting itself was enough of an unknown. An article by Stuart Morgan titled *The Elephant Man* in the March 1994 issue of *frieze* magazine provided important early validation and international exposure; *frieze* rarely had feature articles on individual artists at the time, and even more rarely on a painter. Taking the initiative to gain visibility for his work, Ofili made his first visit to New York and met with Gavin Brown, a London art school graduate just starting up his own gallery. He showed interest. In London, Victoria Miro, whose gallery showed established artists alongside younger artists including Peter Doig and Jake and Dinos Chapman, invited him to participate in a group show, *Painting*, at the end of the year.

FIG. 5
Detail from **Painting with Shit on it** 1993 (p.24)

9.
www.cubittartists.org.uk/index
Accessed on 13 July 2009.

10.
Conversation with the author,
Port of Spain, June 2009.

11.
Ibid.

12.
From an unedited transcript of a conversation between the artist and Ekow Eshun,
Port of Spain, June 2009.

13.
Ibid.

14.
Conversation with the author,
Port of Spain, June 2009.

15.
Ezekiel, chapter 25, verse 17.

16.
Conversation with the author,
Port of Spain, June 2009.

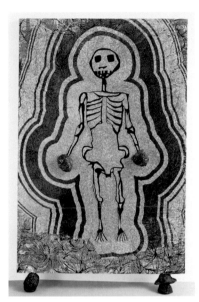

FIG. 6
Them Bones 1995
Acrylic, oil, polyester resin
and elephant dung on linen 182.8 x 121.9

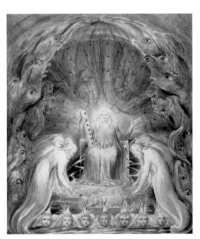

FIG. 7
William Blake
**The Four and Twenty Elders Casting their
Crowns before the Divine Throne** c.1803–5
Pencil and watercolour on paper 35 x 29

The Road to Damascus

At the same time as Ofili was testing the responses of the art world to him and his paintings, he was registering his own response to the culture around him. Since the late 1980s, hip-hop had become a dominant, vernacular, urban art form. The black nationalist group Public Enemy, described by frontman Chuck D as 'CNN for black people', was as much a radical social and political phenomenon as a musical one; Spike Lee's films were packing out cinemas, and there was a newly assertive vibe about blackness that to Ofili felt totally contemporary and necessary. 'You had to decide whether you were going to join the party or not, and for me, there was no choice.'[12] This synergy brought a freedom to incorporate the urban experience, specifically the urban *black* experience, into his work. It gave him licence to make paintings that were unapologetically coming out of who he was and what he was interested in. 'I liked being in the studio and I liked listening to music, and then I realised that what I was thinking of, what I was listening to, was [coming] into what I was making.'[13] He recalls a 'road to Damascus' moment on seeing Quentin Tarantino's *Pulp Fiction* on its UK release in October 1994, a watershed film and instant classic.[14] Ofili loved the character of hitman Jules, played by Samuel L. Jackson, and the legendary scene when he kills a man whilst spouting the words of the prophet Ezekiel with the controlled force of a Baptist preacher:

> …And I will strike down upon thee with great vengeance and furious anger those who attempt to poison and destroy my brothers. And you will know my name is the Lord when I lay my vengeance upon thee.[15]

The revelation that pop culture, the cadences of the biblical prophets, stylised violence and humour could coexist in such powerful and enthralling form was an inspiration to the artist.

Challenged by these vivid concatenations of worldliness, Ofili grew dissatisfied with abstraction as an end in itself – he was interested in the challenge of an overall decorative approach to the painting but, 'if you live in the world, abstraction doesn't do it. I tried it. It had a big place in my work for a time'.[16] In *Them Bones* the figure, in skeletal form, is reintroduced as a central motif, with a cartoon-like exaggeration and dungballs for hands. Ofili further extended his inclusive, vernacular aesthetic through the use of collaged cut-outs from black music and porn magazines. Ever open to an eclectic range of influences, Ofili's imagination was fired by historic art as well as contemporary pop culture. *7 Bitches Tossing their Pussies before the Divine Dung* (p.25) was a direct response to William Blake's *The Four and Twenty Elders Casting their Crowns before the Divine Throne* c.1803–5, which he had seen and sketched at the Tate Gallery in 1995. (*Satan* was another painting directly inspired by Blake, in this instance *Satan in his Original Glory: 'Thou wast Perfect till Iniquity was Found in Thee'* c.1805). Drawn to the compelling visions of Blake's radical, spiritual imagination, Ofili also adopted the urgent imaginings of porn to evoke a similarly subliminal state. It is all done with the utmost bad taste and good

humour. Ofili's '7 Bitches' of the title substitute for Blake's seven angelic heads, whilst the 'Divine Dung' channels energy to the surrounding cosmos of carnal pleasure. At the end of 1995, both these Blake paintings were shown in his first solo show since leaving college, at Gavin Brown's recently opened gallery in New York.

Afrodizziac

Almost visibly accelerating and changing gear, in 1995 Ofili showed internationally, not only paintings, but also drawings and prints. He was selected for a number of major exhibitions including *Brilliant! New Art From London*, curated by Richard Flood, for the Walker Art Center, Minneapolis and the Contemporary Arts Museum, Houston. This was a landmark show of twenty-two artists representing the 'explosion' of work on the British art scene, whose 'aesthetically diverse and provocative artworks are united by a shared interest in ephemeral materials, unconventional presentation, and an anti-authoritarian stance that lends their objects a youthful, aggressive vitality'.[17] Ofili also featured in *The British Art Show 1995*, a review of new talent conducted every five years which toured to major cities in the UK. In the same year he showed work in New York, Los Angeles, Berlin, Hamburg and London, ranging from projects with cult art world status such as *Cocaine Orgasm* (a show organised by the London artist-collective BANK) to the long-established *John Moores Contemporary Painting Prize* at the Walker Art Gallery in Liverpool. In 1996 he scaled up the paintings from six by four feet to eight by six feet, and showed the new work at his first solo show at Victoria Miro Gallery, *Afrodizziac*. His 'Afro' paintings are hypercharged; ripples of psychedelic colour fizz and crackle through efflorescent surfaces. Ofili was pushing the embellished canvas to excess, even making double paintings with phosphorescent backgrounds and glowing after-

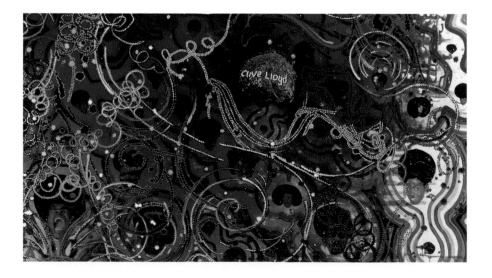

17.
Press release, Walker Arts Center, Minneapolis, no.133, 22 September 1995.

18.
'Thelma Golden & Chris Ofili: Conversation', in *Chris Ofili*, New York 2009, p.236.

19.
Kodwo Eshun, 'Plug Into Ofili', in *Chris Ofili*, exh. cat., Serpentine Gallery, London 1998, unpaginated section.

20.
Ibid.

FIG. 8
Detail from **Afrodizzia (Second version)** 1996 (p.31)

images. Reflecting on the work of that period, Ofili recalls that 'it was about trying to get as deeply lost as possible in both the process of painting and the painting itself'.[18] The collaged faces of black personalities circle like celebrity satellites. Afro hairdos painted onto the cut-out heads silhouette each one with a black halo. Map pins stuck into the dung balls (a new signature technique) spell out a roll of honour of Afro-centricity: James Brown, Miles Davis, Don King, Frank Bruno, Clive Lloyd and Cassius Clay/Muhammad Ali (detail, opposite page). Turning a Hogarthian eye on the contemporary vogue for Afro-celebration, Ofili also created the potent caricature of Captain Shit. Encircled by black stars, Ofili's red-caped demigod (born of Marvel comic antecedents) is sex god and soul icon, bestriding the universe in his spandex suit with full pop baroque splendour. Several pictures in the series, continued over several years, show Captain Shit mobbed by adoring fans (p.47). In one painting, the audience is black, in another, white: the paradox of contemporary black culture being avidly consumed by a white audience is wryly noted by Ofili and played back to his own audience.

Far from feeling constrained by the polemics and theorisation of blackness, Ofili was opening up his paintings to the cultural fodder he was drawn to, responding with the cut and paste mentality of the hip-hop generation. In a show in Amsterdam in 1996 he made a decorative wall painting using collaged imagery whilst tuning in to a screening of the Black Audio Film Collective's 1995 film *The Mothership Connection*. But Ofili has claimed for himself a permissive engagement in all kinds of culture: 'My project is not a PC project. That's my direct link to blaxploitation. I'm trying to make things you can laugh at. It allows you to laugh about issues that are potentially serious. There are no rules …'[19] The stereotypical slang of hookers and pimps in blaxploitation films and the misogynistic rants of rappers become infused within the paintings in a pungent mix of hedonism and realism. Parodies of sexuality and ethnicity were all around him, not least in the all-hours, all-weathers sex and drugs trade conducted in a corner of the car park at his studio building in Kings Cross (to which he had moved, from Fulham, in 1996). 'I hated it when I first moved in. Everything that you can imagine happens in a public toilet happens here, plus more.'[20] But even this hardcore subculture could be brought within the ambit of his paintings; Ofili could buy porn magazines in the bead-fringed bookshops on the streets of King Cross just as easily as paint from his art supplies shop. The paintings that came from this, *Blossom*, *Foxy Roxy*, *Rodin* and *Pimpin ain't easy* (pp.35, 37 and 39), all featured in his first solo show at Contemporary Fine Arts in Berlin at the end of 1997 (completing a hat-trick of gallery representation in the UK, Germany and the US). *Pimpin ain't easy but it sure is fun*, the title of the show, was printed on the invitation card over an image of Ofili, smiling at the wheel of his beloved 1973 Ford Capri 1600 XL, at night. The title painting depicts a cartoon pimp/penis character with a clown face (p.39); the background is painted in acrylic the colour of cheap gold, with floating insect-like figures comprising black celebrity male faces squatting on the splayed legs of crotch shots. The formidable women in this series of pictures, whether based on blaxploitation heroines or porn

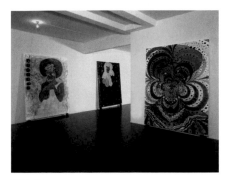

FIG. 9
Installation view, **Mothership Connection**, Stedelijk Museum Bureau, Amsterdam, 1996

FIG. 10
Installation view, **Pimpin' ain't easy but it sure is fun**, Contemporary Fine Arts, Berlin, 1997

queens, all bask in their outrageous sexiness. In the same show, to sound a different note, Ofili included *She* (p.41), an altogether different representation of the black female subject, one that radiates a regal poise.

Ofili's growing reputation was consolidated with an exhibition at Southampton City Art Gallery which travelled to the Serpentine Gallery, London, in 1998, and then to the Whitworth Art Gallery, Manchester (1998–9) – a popular and critical success which elicited a nomination for the 1998 Turner Prize (fellow nominees were Tacita Dean, Sam Taylor-Wood and Cathy de Monchaux). With the Whitworth exhibition still running, Ofili produced several new works to add to those paintings and drawings that were available for his Turner Prize exhibition at the Tate Gallery. Mindful of the wider public domain of the Turner Prize, Ofili included a tender painting which drew particular attention. *No Woman, No Cry*, one of a series of female heads from this period, was made more poignant by its inspiration – the public inquiry into the racist murder of a south London teenager, Stephen Lawrence, in 1993. Watching the boy's parents interviewed by the media, Ofili was deeply moved by the way in which Doreen Lawrence's overwhelming silent grief at her son's tragic death became transformed: with each successive media interview she became ever stronger in spirit and emboldened to speak with great dignity. The case exposed the institutional racism of the Metropolitan Police in failing to respond appropriately at the crime scene and in bungling the prosecution of the alleged killers. Ofili's image of maternal grief is composed with the taut control of a Renaissance portrait and invested with the aura of a votive object: in each teardrop and in the pendant necklace is a cameo of the murdered boy (detail opposite). When Ofili, odds-on favourite, was awarded the Turner Prize, aged thirty, there was much comment about the fact that he was the first painter to win since Howard Hodgkin in 1985 and also that he was the first black artist to win the Prize. The dung balls were loved by cartoonists and, by the end of the year, Ofili was one of the few young contemporary artists whose name and work was known to a wider British public.

Even the media response to the Turner Prize could scarcely have prepared Ofili for the furore the following year, when the *Sensation* exhibition of Charles Saatchi's collection which had been shown at the Royal Academy in 1997, and then in Berlin, opened at the Brooklyn Museum, New York in September 1999. One of the paintings he showed, *The Holy Virgin Mary of* 1996, became the target of vituperative public debate. Wholly representative of Ofili's paintings of the mid-1990s, it twinned powerful but polarised aspects of human experience: 'One of the starting points was the way black females are talked about in contemporary gangsta rap. I wanted to juxtapose the profanity of the porn clips with something that's considered quite sacred. It's quite important that it's a Black Madonna.'[21] Ofili's artistic ambition to fuse sexual, religious and ethnic stereotypes collided with the political ambitions of then New York mayor Rudy Giuliani, preparing to run for the US Senate the following year against likely Democratic candidate, Hillary Clinton. Seeing an opportunity to score political points, Giuliani singled

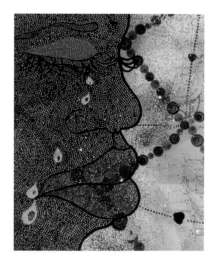

FIG. 11
Detail from **No Woman, No Cry** 1998 (p.45)

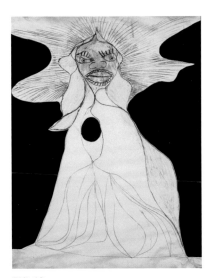

FIG. 12
Drawing for **The Holy Virgin Mary** 1996
Charcoal on paper with cutaway 205.5 x 151.5

21.
Ibid.

22.
Guardian, 24 September 1999, p.1.

23.
Jonathan Jones, 'Paradise Reclaimed',
Guardian, magazine section, 15 June 2002.

24.
Ibid.

out *The Holy Virgin Mary* for attack without ever having seen the show. 'It offends me', he opined. 'We will do everything that we can to remove funding for the Brooklyn Museum until the director comes to his senses and realises that if you are a government-subsidised enterprise, then you can't do things that desecrate the most personal and deeply held views of people in society.'[22] In a bizarre sublimation of politics, art and popular entertainment, Ofili even featured in the title sequence to an episode of *The Simpsons* aired just after the controversy (Bart is seen at the blackboard doing lines: 'I will not create art from dung').[23] Interviewed at the time, Ofili commented straightforwardly if somewhat disingenuously: 'As an altar boy, I was confused by the idea of a holy Virgin Mary giving birth to a young boy. Now when I go to the National Gallery and see paintings of the Virgin Mary, I see how sexually charged they are. Mine is simply a hip-hop version.'[24] An artist less sure of his purpose might have been dismayed by the ferocity of the attack, but Ofili could take heart from witnessing at first hand the extraordinary impact one handmade image could have in the world's most powerful, post-industrial nation.

Monkey Magic

After the Turner Prize, Ofili felt the need to withdraw from public scrutiny and in 1999 moved studios from Kings Cross to his house in east London. He commissioned the architect David Adjaye, a friend who had graduated with him from the Royal College of Art, to design the house to create a studio at the rear. He recalls that he retreated to such a degree – staying home and no longer circulating at gallery openings – people thought he had moved away (so much so, he says, that when he did move, no one really noticed). He cleared his head by focusing on drawing; it was a concentrated way of working that offered relief from the demands of painting. Nonetheless, this retreat created the space for a new body of work to develop. In a trio of paintings called *Monkey Magic*, a waistcoated monkey (based on a Warhol collage) holds up a chalice from which emanate a triad of temptations, a morality tale of Sex, Money and Drugs. This motif seemed to offer Ofili more, however, and he started to make some monochrome paintings, first a red one, then black, then green. For a while these three works might have formed a triptych, but he kept on painting them as if in a meditative state. The accretion of the paintings generated momentum. He had never had so many paintings lined up against his studio wall. Soon he had twelve.

Freedom One Day

These paintings opened up a more introspective mood, and the religious overtones of the iconography – the holding up of the chalice, as in the Christian sacrament of communion – invoked mystery rather than confrontation. Ofili recalls no grand design; the paintings which became *The Upper Room* 'just came together' (pp.80–95).

He made a thirteenth painting, larger than the rest, to occupy the end wall between the two flanks of monkeys, towards which they all face. During the three years that he had been making the paintings, Victoria Miro Gallery had moved from Cork Street to Wharf Road in north London, to a much larger, former factory building on two floors. Ofili and Adjaye collaborated to design the hermitage structure that these paintings seemed to require and found the perfect material: walnut with a split-grain, mirrored effect that echoed the symmetry within the paintings. Visitors to the exhibition *Freedom One Day* would climb the steep staircase by the entrance door, and enter a long corridor before turning into a nave-like space with a rounded apse. No one could have anticipated that a young artist in London on the cusp of t1he twenty-first century would spend three years working on a grand painting cycle on the theme of the Last Supper, and it astonished all who saw it. The long approach was intended to slow the viewer down. Entering the wooden casket invoked the sudden change in emotional tempo experienced upon entering a chapel. The highly reflective paintings, intensely lit, cast a mirrored image in a pool of colour onto the walnut floor. They radiated the opulence of pigment applied in oil, acrylic, ink, and ornamented with glitter, dung, map pins, and gold leaf. The subject was strange and ambiguous; for all the Christian symbolism, *The Upper Room* emanated an occult mystery. Here was a work that declared the artist's ambition to go beyond the singular experience of individual paintings; this was an ecumenical, collective invitation to transcendence through the senses and the imagination.[25]

As well as *The Upper Room*, the 2002 exhibition *Freedom One Day* also presented, on the ground floor, a further group of works indicating another new direction in Ofili's practice. In 2000 he had made a trip to Trinidad; invited several times over a period of years to take up an artist's residency there, Ofili had resisted, thinking that were he ever to go to Trinidad it would be for a holiday and not to work. But coming at a moment when he was curious about what might be next, he suggested that the organisers also invite his friend Peter Doig, who had lived there as a child. For both of them, the residency planted the unforeseen thought that they might both return to live there, Doig moving to the island with his family in 2003. Ofili took home a found image – a stylised, touristic cliché of lovers under a palm tree – from which derived this new narrative series. Invoking the utopian lyrics of late 1960s/ early 1970s pop soul, and using only the red, black and green of Marcus Garvey's Pan-African flag, Ofili's paintings told a story of romantic enchantment.

Within Reach

Whilst the *Freedom One Day* show was still on view in London, Ofili was invited to represent Britain at the 2003 Venice Biennale – one of the highest honours for any artist, but a heavy commitment too, since the show had to be developed within a matter of months. Ofili had planned to make the move to Trinidad immediately after his London show, so when asked to undertake the Venice commission, he had no studio, and was looking forward to a quiet few months. After some hesitation

FIG. 13
Chris Ofili
Drawing for **The Upper Room** 2001
Ink on paper 29.7 x 21

25.
At an early stage, Ofili imagined that visitors would proceed downstairs where they would encounter three further paintings of the Crucifixion, Confession and Resurrection, but this idea never came to be developed.

26.
See Okwui Enwezor's authoritative analysis of this project, 'Shattering the Mirror of Tradition', in *Chris Ofili*, New York 2009, pp.142–56.

27.
Christy Lange, 'Love in a Red Hot Climate', *Observer*, 15 June 2003.

28.
From the unedited transcript of a conversation between the artist and Ekow Eshun, Port of Spain, June 2009.

FIG. 14
Installation view, **Within Reach**, British Pavilion,
Venice Biennale, Venice, 2003

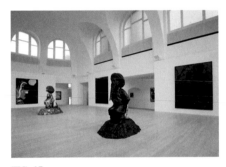

FIG. 15
Installation view, **The Blue Rider Extended
Remix**, kestnergesellschaft, Hanover, 2006

he accepted, got himself another studio and started again. Ofili again worked
with Adjaye to develop the conceptual and physical architecture of the exhibition.
The show that resulted, *Within Reach*, brought to a crescendo Ofili's symbolic
romance of the black male and female, enshrined in the canonical myth of
creation.[26] Entering the Pavilion, the viewer crossed a threshold into a world of
colour saturation and sensory intoxication. The paintings blazed within a total
environment of red, black and green; in the central chamber, the paintings were
crowned by a vortex of mirrored glass. All natural light was shut out and artificial
light jacked up to create a hothouse cornucopia. Ofili remarked that the space
was 'a mixture between a confessional and a VIP lounge'.[27]

The Reflective Turn
Unsurprisingly after such a crescendo, Ofili needed to go into neutral,
and find a new direction.

> You see, over the [period] from '87 when I first started working, to *Within
> Reach* in 2003, I'd made some changes, but I was always progressing –
> I was adding, I was refining. And then the way I was working physically
> meant that at some point I was going to reach a dead end. I couldn't
> suddenly start taking the elephant dung off and then start taking the pins
> away and then peel back the resin ... I had to get off the horse, you know,
> and walk. And that's what I decided to do.[28]

He did it the way he knew, through working on paper. The execution of his paintings
had always been laborious. Images evolved, rarely planned beyond an initial starting
motif. Now Ofili relaxed into working quickly in watercolour and pencil, moving
through images, trusting and enjoying the fluency this allowed. A large group of
his previously unseen watercolours, *Afromuses*, was shown at The Studio Museum
in Harlem, in 2005, offering a very different focus on his production. Increasingly,
the artist felt cornered in London. The energy and optimism of the London art scene
in the mid-1990s had changed; instead there was a creeping claustrophobia. Ofili was
ready to make another move.

He took a new studio and quietly started working again, this time on a bigger scale
than before. What resulted was an exhibition, *The Blue Rider*, at Contemporary
Fine Arts, Berlin in 2005 (reprised in Hanover the following year as *The Blue Rider
Extended Remix*) in which change was evident at every turn. A fluid presentation
of work in many media, the exhibition included paintings, works on paper and –
against expectation – sculptures in bronze and nickel silver. Paintings and drawings
on paper combined gouache, ink, pastel, charcoal, and aluminium leaf. A new
voluptuousness enters the lexicon and the palette narrows to midnight blues
and silvers. The colour blue represented a challenge for him that seemed right for
the moment. Light, never a descriptive presence in his paintings, enters the work
in negative through the heavy pregnant blue of night, and reflects off the aluminium

leaf in low-hanging moons, serpents and quicksilver glances. Characteristically audacious, Ofili's sculptures were not in the least tentative – they spoke of an artist giving himself licence to experiment again, a natural corollary, perhaps, of his recent abandonment to the linear dimensionality of drawing.

When it came, Ofili's move to Trinidad in 2005 was typically decisive, led by instinct that the island would offer sustenance. The island the paintings respond to is one of surprise; of swarms of bats; the sudden half hour when day turns to night; figures half seen or imagined in the gloaming. The natural world asserts itself and demands watchfulness. On any routine journey up the hillsides, power lines might have fallen, or a laden truck slid off the treacherous chicanes of the mountain roads. Ofili's studio is a white cottage set high on Lady Chancellor Hill, overlooking the city and, in the distance, the port. Its three small rooms are not much bigger than the studio from his student days at Chelsea. He works up close to the paintings, with no viewing distance, and no distractions other than the weather, passing insects, the occasional trill of his mobile and, still, his music. He didn't know if he could work in Trinidad, but wanted to try, knowing the challenge he had set himself: to relearn, to start again.

The first fruits of his island existence were revealed in *Devil's Pie* at David Zwirner gallery, New York in 2007. Again he showed paintings alongside sculpture, prints and drawings, an assertion of his freedom to move across media at will, and evidence of a productive state of mind. Shifting up in scale again, the paintings are more visibly led by drawing, their languorous contours amplified with colour, hot and sharp. There is a new urgency and sense of daring. The narratives are more complex: moments of emotional and spiritual intimacy are arrested by temptation and guilt. Trinidad pervades the work: 'I think there's a sincerity about the place that allows me, encourages me to surrender to it, and allows the work to retain some of that sincerity of form, of light and shade, of narrative, of composition, of dynamism, of many, many feelings of emotion.'[29]

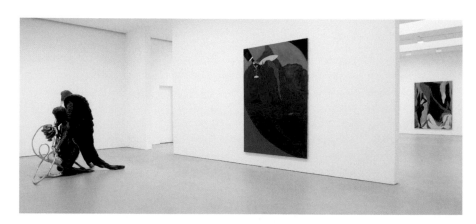

FIG. 16
Installation view, **Devil's Pie**, David Zwirner, New York 2007

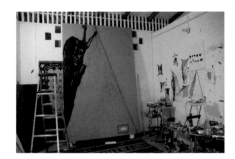

FIG. 17
Habio Green Locks (in progress) 2009
Photograph by the artist
(see p.147)

29.
Ibid.

30.
W.J.T. Mitchell, *What Do Pictures Want?
The Lives and Loves of Images*, Chicago
and London, 2005, p.8.

31.
Ibid., pp.35–6.

32.
From an unedited conversation between
the artist and Ekow Eshun, Port of Spain,
June 2009.

33.
Mitchell 2005, p.10.
The interpolation is my own.

What Do Pictures Want?

Coincidentally, and unknown to Ofili, in the year he moved to Trinidad, the American author W.J.T. Mitchell brought out a book called *What Do Pictures Want?* A playful investigation of the power of images, it provides a specific thought that illuminates Ofili's continual conjuring with iconography. Arguing that 'magical attitudes towards images are just as powerful in the modern world as they were in so-called ages of faith', Mitchell contends that 'the double consciousness about images [they aren't alive/they are alive] is a deep and abiding feature of human responses to representation. It is not something that we "get over" when we grow up, become modern, or acquire critical consciousness.'[30] More than most of his generation, Ofili has tested and proved this assertion, breaching our modernist incredulity to create paintings that teem with ecstatic life, forging his own iconography that avows religion and popcorn culture, ethnicity and authenticity, bums and tits. Their skins shine with the ardour of faith: his paintings inexorably cast their spell. Answering his own question, Mitchell writes:

> If one could interview all the pictures one encounters in a year, what answers would they give? Surely, many of the pictures … would want to be worth a lot of money; they would want to be admired and praised as beautiful; they would want to be adored by many lovers. But above all they would want a kind of mastery over the beholder … The paintings' desire, in short, is to change places with the beholder, to transfix or paralyse the beholder, turning him or her into an image for the gaze of the picture in what might be called "the Medusa effect".[31]

In Ofili's work, this reached its apogee in the entrancement effected in *The Upper Room* and *Within Reach*. If this were a classical myth one might imagine that the painter thus became momentarily paralysed, himself transfixed by the spell of the paintings.

So in 'beginning again', in the seclusion of his hillside cottage, how is Ofili's relationship to the picture different from before? 'I think there are more unknowns in the work for me now, in the narratives. But I'm more comfortable with that … Maybe because I'm at the beginning of something new. Just the same as *Painting with Shit on it* was at the beginning of something …'[32] Like the environment in which he now lives, his new paintings are unpredictable, less driven by a process of accretion and more led by intuition. His engagement with the paintings is ever more personal. Before, Ofili brought the world into his paintings; whether the dung of Zimbabwe or the sexual antics of Kings Cross, they simulated the thrills of being alive. Now, making paintings in a studio with doors and windows wide open to the island breeze or sudden downpour, there is a sense in which the artist enters the world of the painting. Ofili's confidence is intrepid (there is no knowing where it will lead) and modest (ego is subsumed in a spirit of enquiry). There is a sense that he is listening in a different way to what the painting wants. Or as Mitchell would have it, 'We [as viewers, and perhaps artists most of all] need to reckon with not just the meaning of images but their silence, their reticence, their wildness and nonsensical obduracy.'[33] That seems a good enough place to begin.

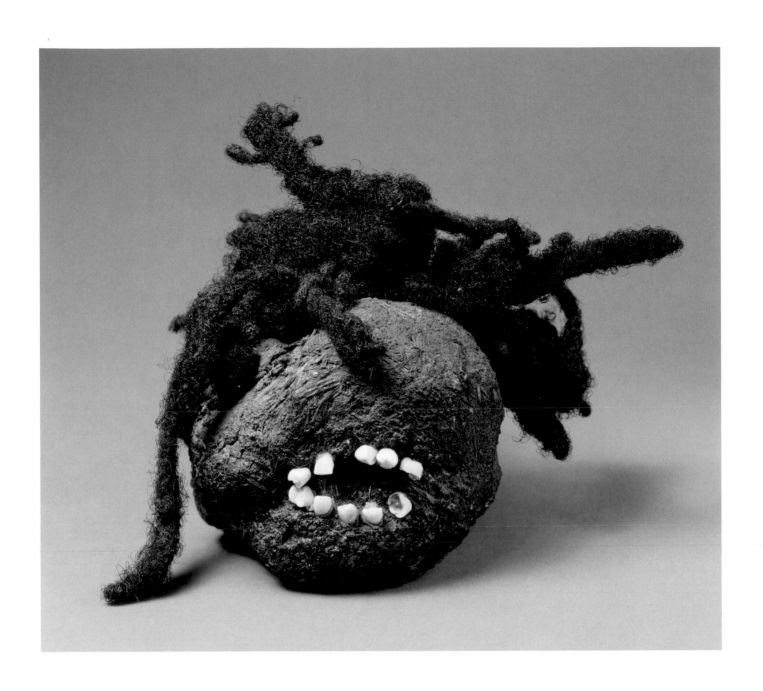

Shithead 1993
Human teeth, artist's hair, polyester resin
and copper wire on elephant dung 11.5 x 18.5 x 18.5

Painting with Shit on it 1993
Oil, polyester resin, pigment and elephant
dung on canvas 182.8 x 121.9

7 Bitches Tossing their Pussies Before the Divine Dung 1995
Oil, polyester resin, paper collage, glitter, map pins and elephant
dung on linen 182.8 x 121.9

Blind Popcorn 1995
Acrylic, oil, polyester resin, paper collage,
glitter, map pins and elephant dung on
linen 182.8 x 121.9

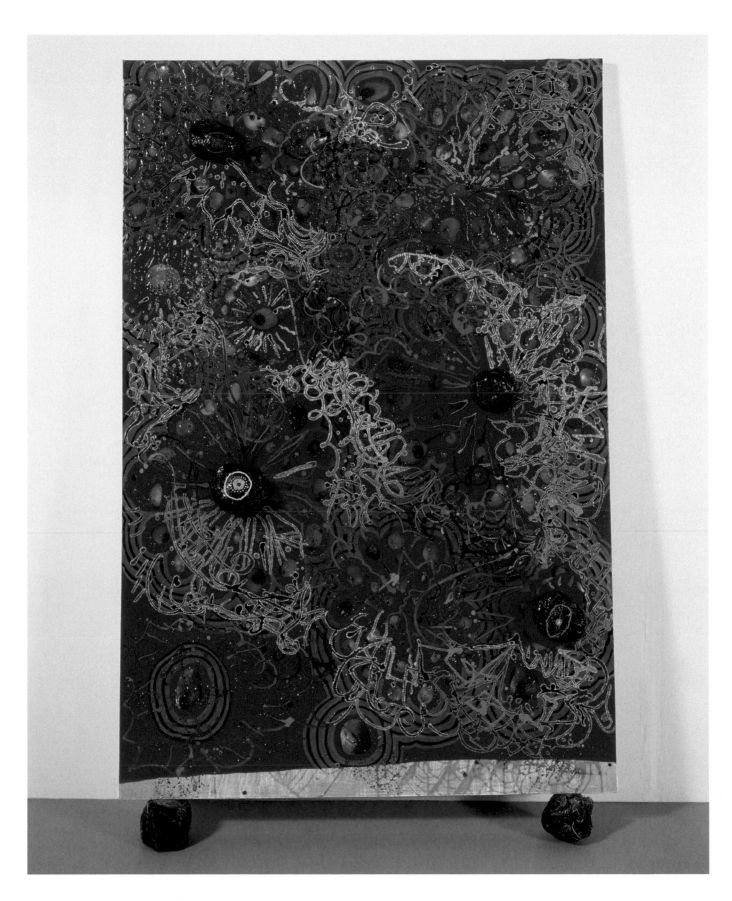

Popcorn Tits 1995
Acrylic, oil, polyester resin, paper collage,
glitter, map pins and elephant dung on
canvas 182.8 x 121.9

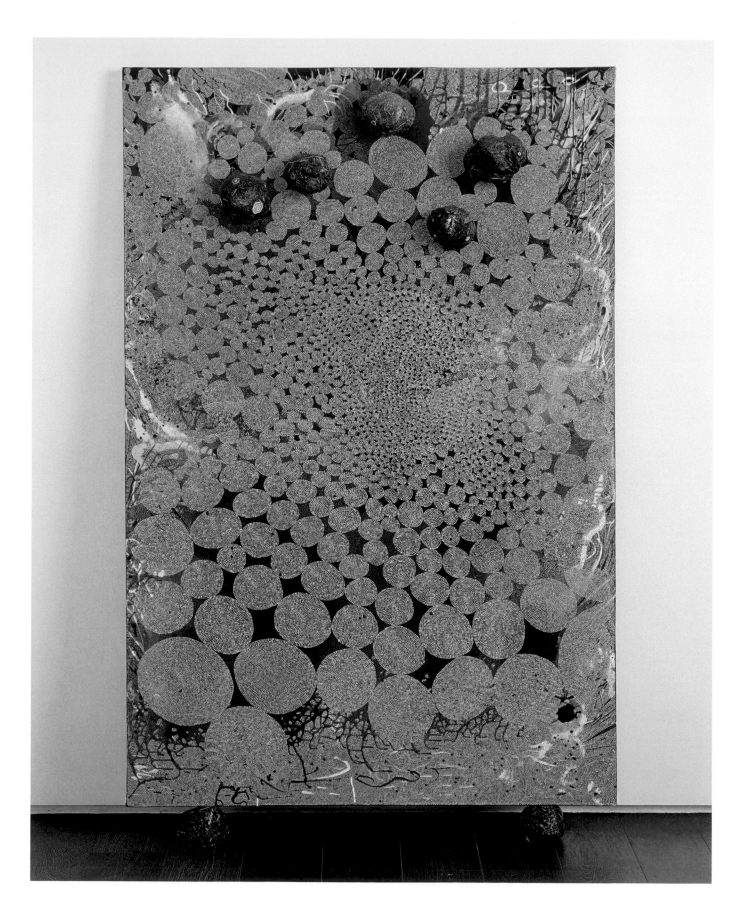

Spaceshit 1995
Acrylic, oil, polyester resin, map pins
and elephant dung on linen 182.8 x 121.9

Afrodizzia (Second version) 1996
Acrylic, oil, polyester resin, paper collage,
glitter, map pins and elephant dung
on linen 243.8 x 182.8

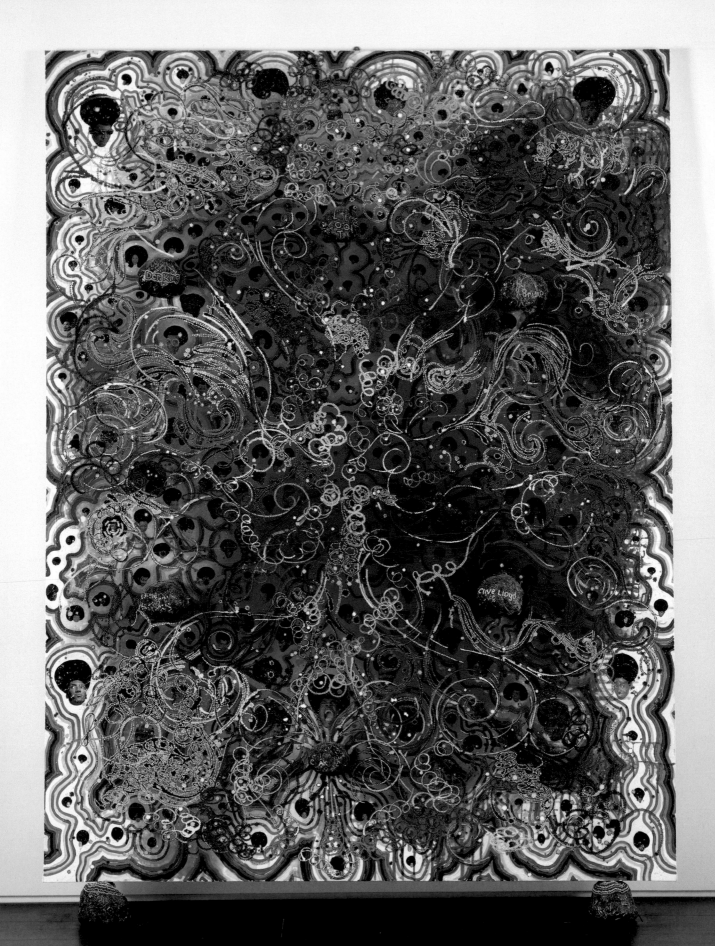

The Holy Virgin Mary 1996
Acrylic, oil, polyester resin, paper collage,
glitter, map pins and elephant dung
on linen 243.8 x 182.8

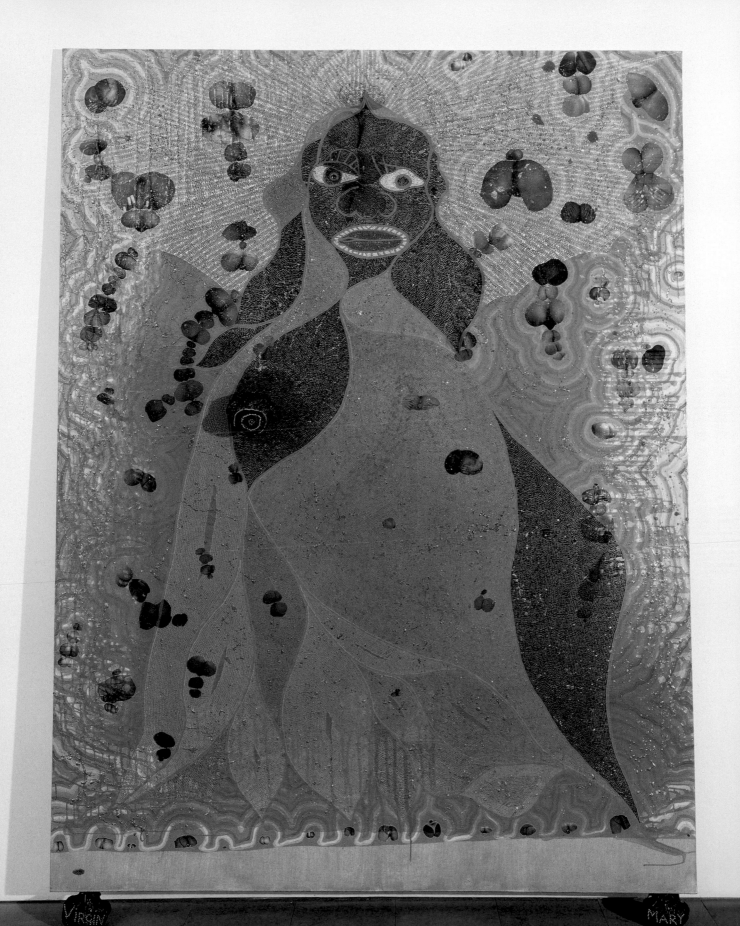

Blossom 1997
Oil, polyester resin, glitter, map pins
and elephant dung on linen 243.8 x 182.8

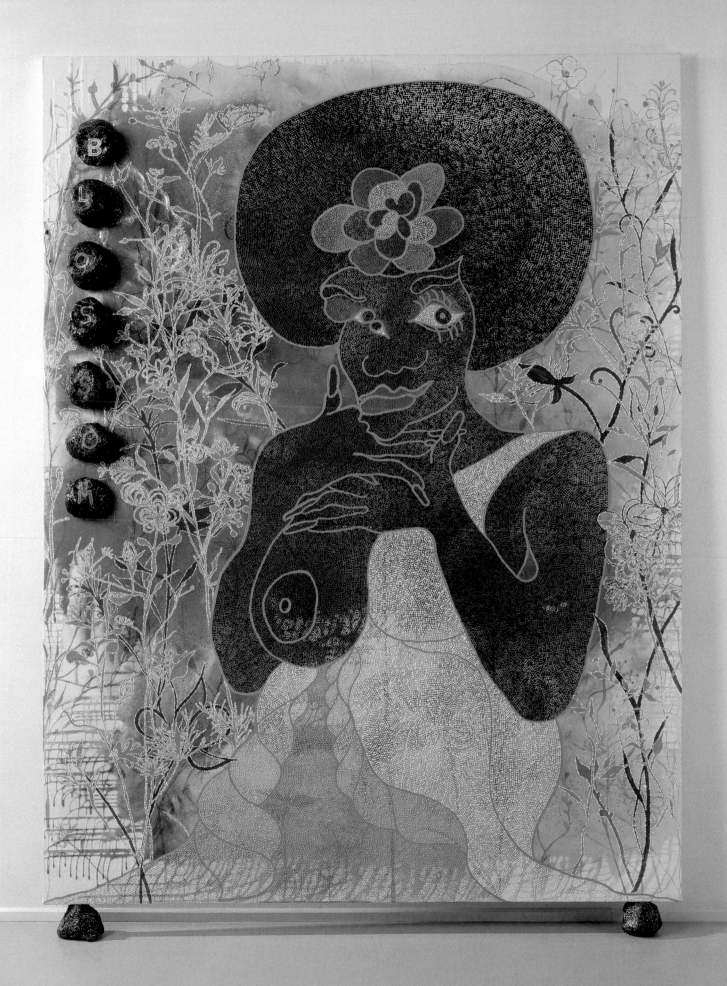

Foxy Roxy 1997
Acrylic, oil, polyester resin, paper collage,
glitter, map pins and elephant dung
on linen 243.8 x 182.8

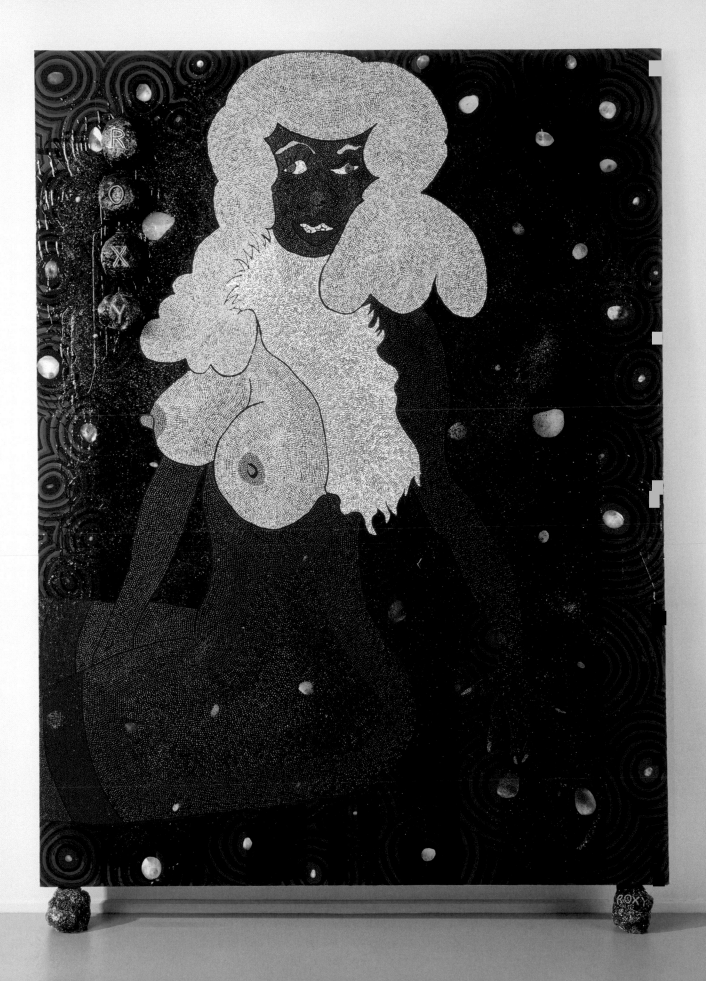

Pimpin' ain't easy 1997
Oil, polyester resin, paper collage,
glitter, map pins and elephant dung
on linen 243.8 x 182.8

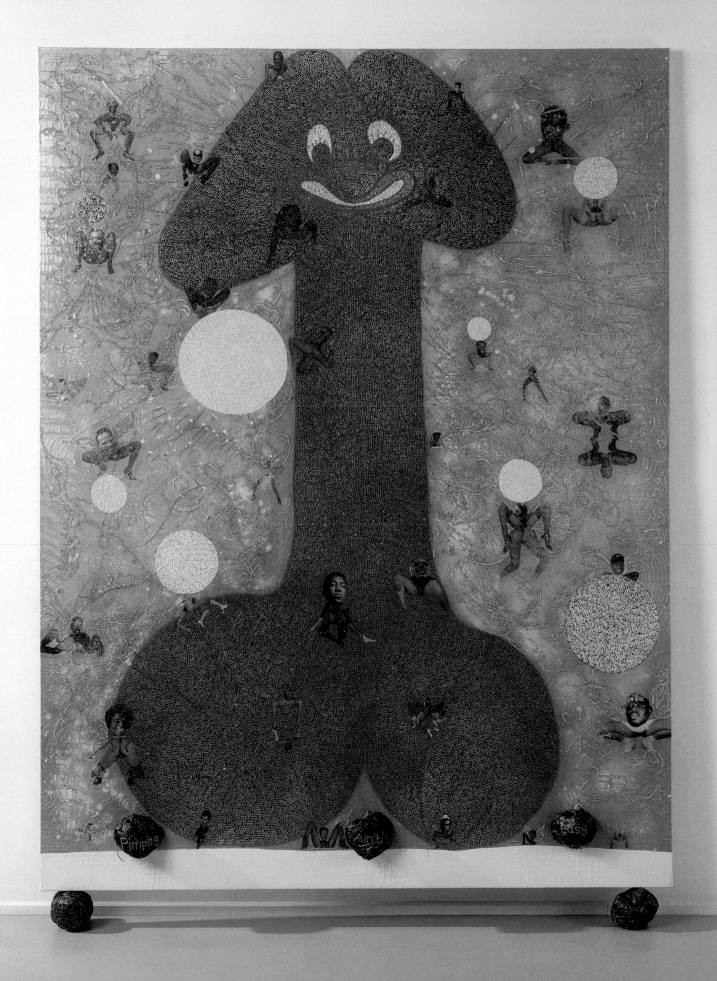

She 1997
Acrylic, oil, polyester resin, paper collage,
glitter, map pins and elephant dung
on linen 243.8 x 182.8

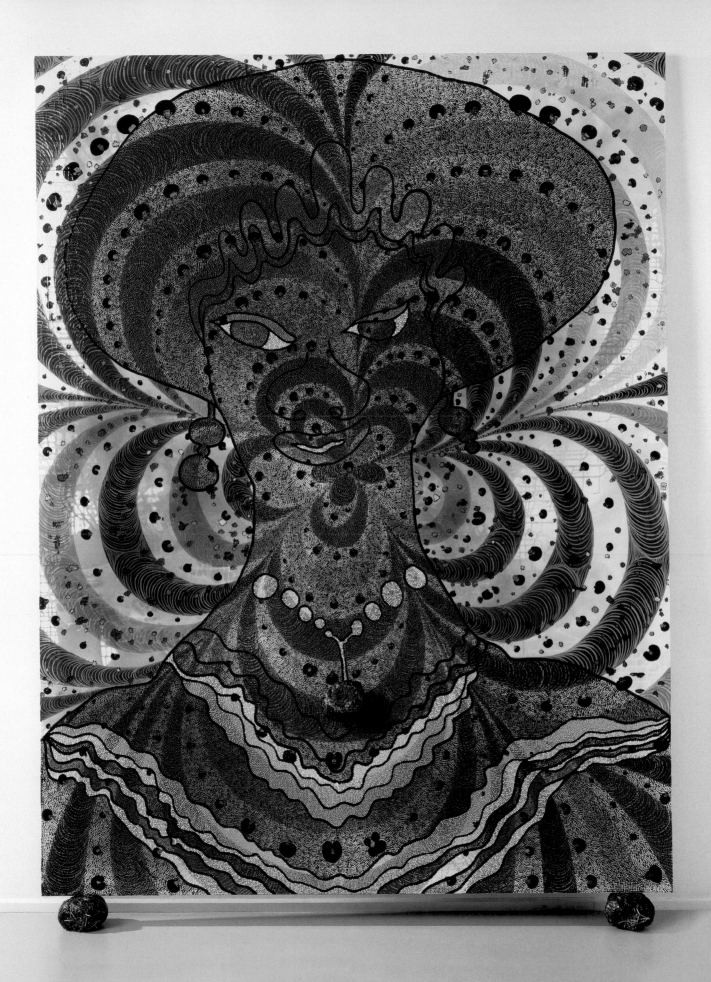

Two Doo Voodoo 1997
Acrylic, oil, polyester resin, paper collage,
glitter, map pins and elephant dung
on linen 243.8 x 182.8

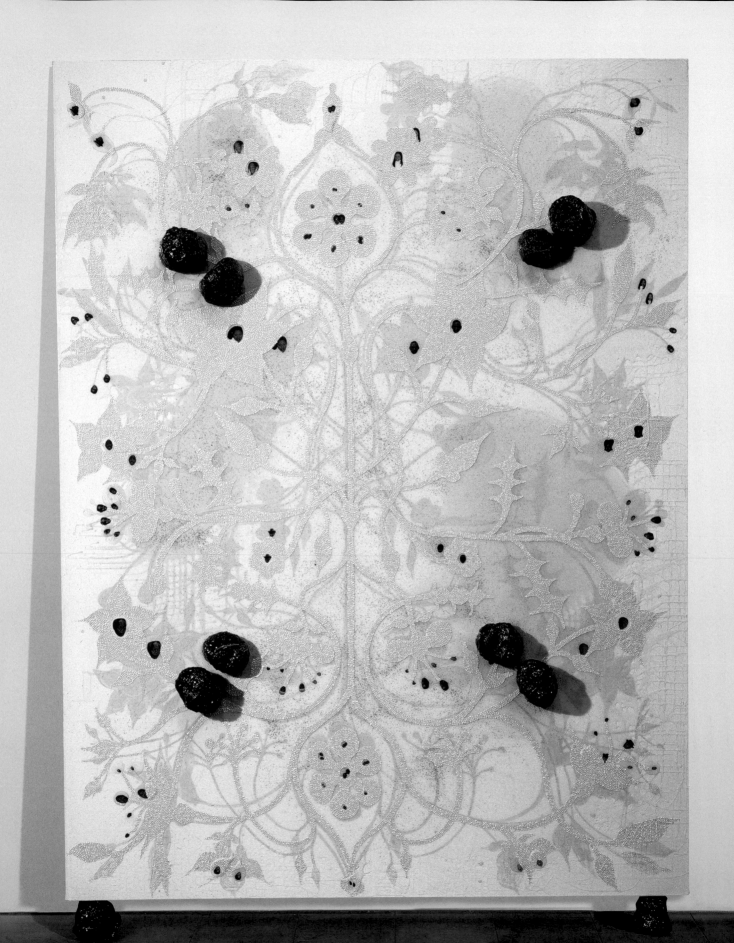

No Woman, No Cry 1998
Acrylic, oil, polyester resin, pencil,
paper collage, glitter, map pins and
elephant dung on linen 243.8 x 182.8

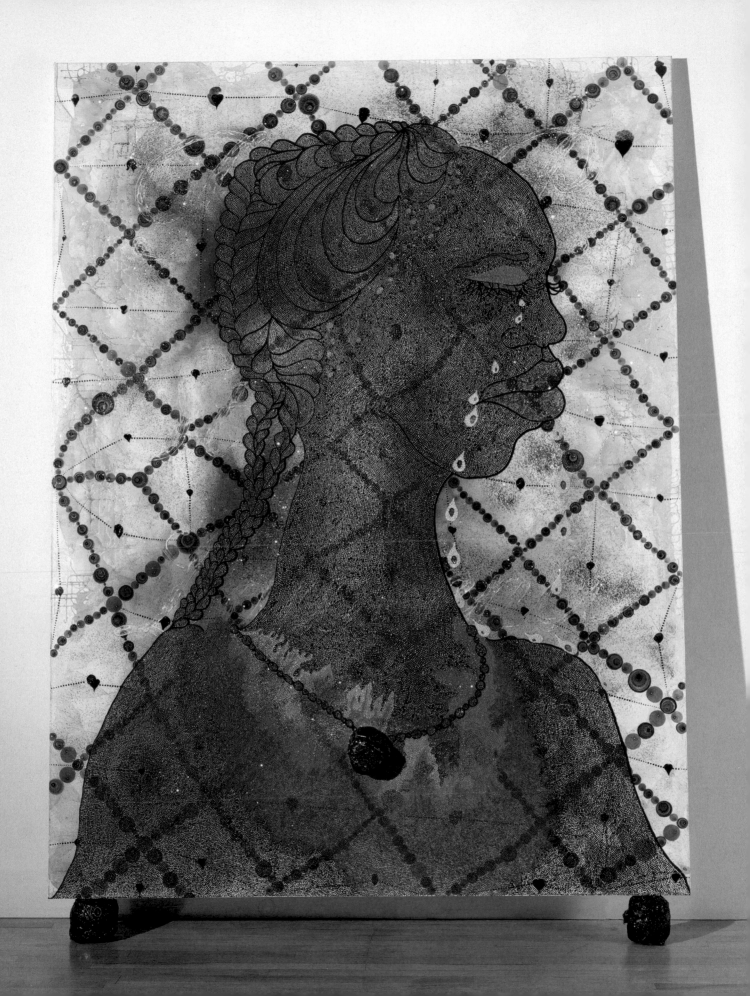

**The Adoration of Captain Shit
and the Legend of the Black Stars** 1998
Oil, acrylic, polyester resin, paper collage,
glitter, map pins and elephant dung
on linen 243.8 x 182.8

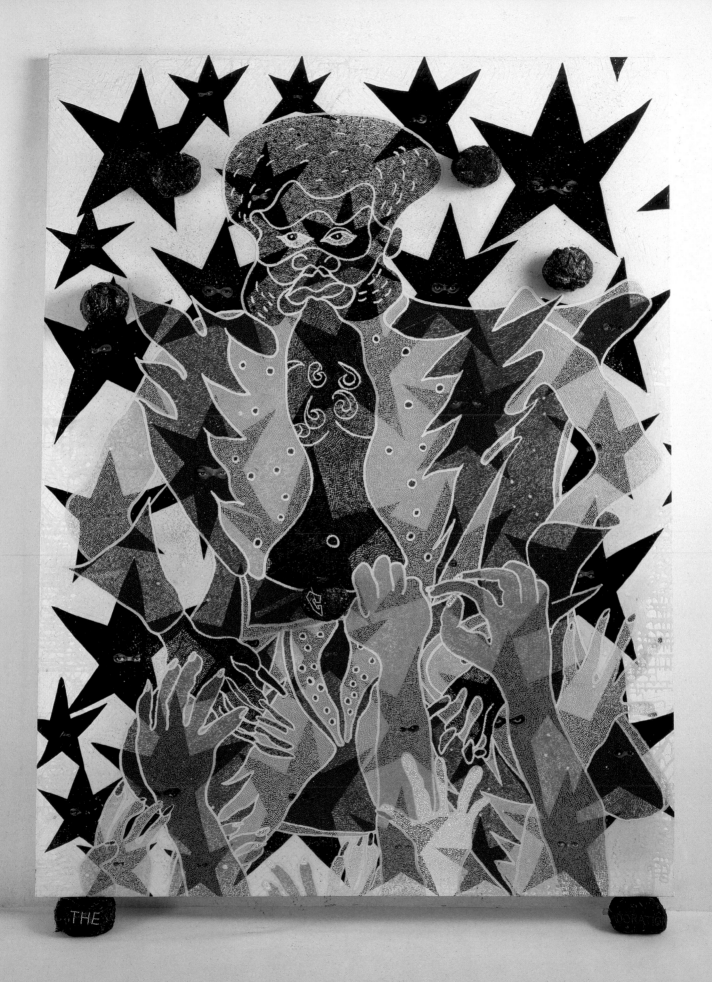

Third Eye Vision 1999
Oil, acrylic, paper collage, glitter, polyester
resin, map pins and elephant dung
on linen 243.8 x 182.8

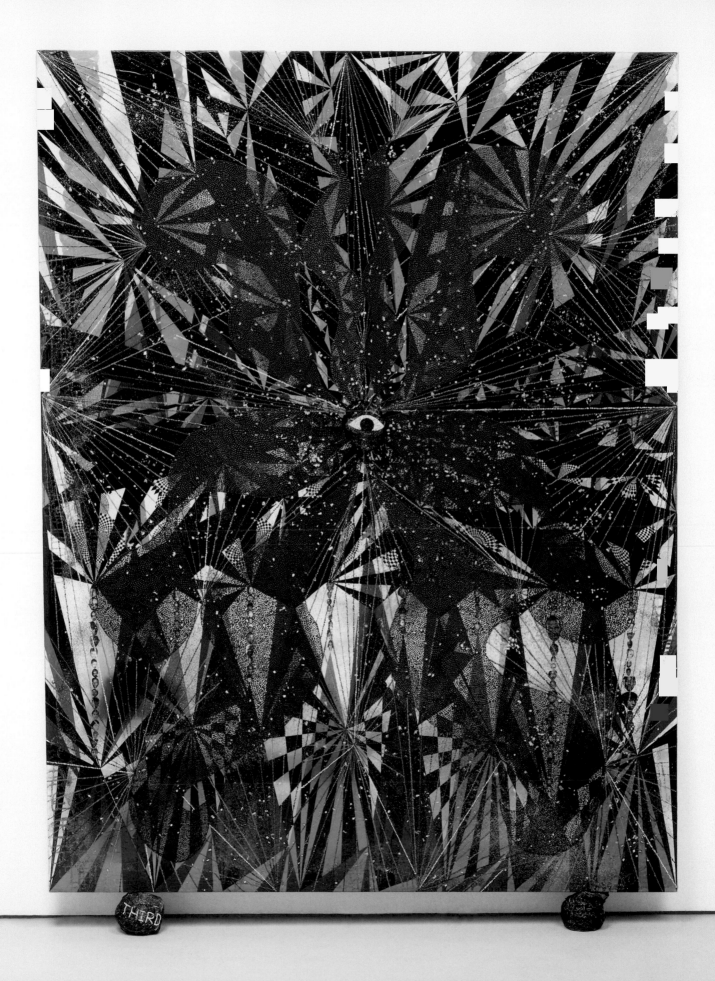

Prince amongst Thieves 1999
Acrylic, oil, paper collage, glitter,
polyester resin, map pins and
elephant dung on linen 243.8 x 182.8

Afro 2000 (overleaf)
Pencil on paper 56 x 76

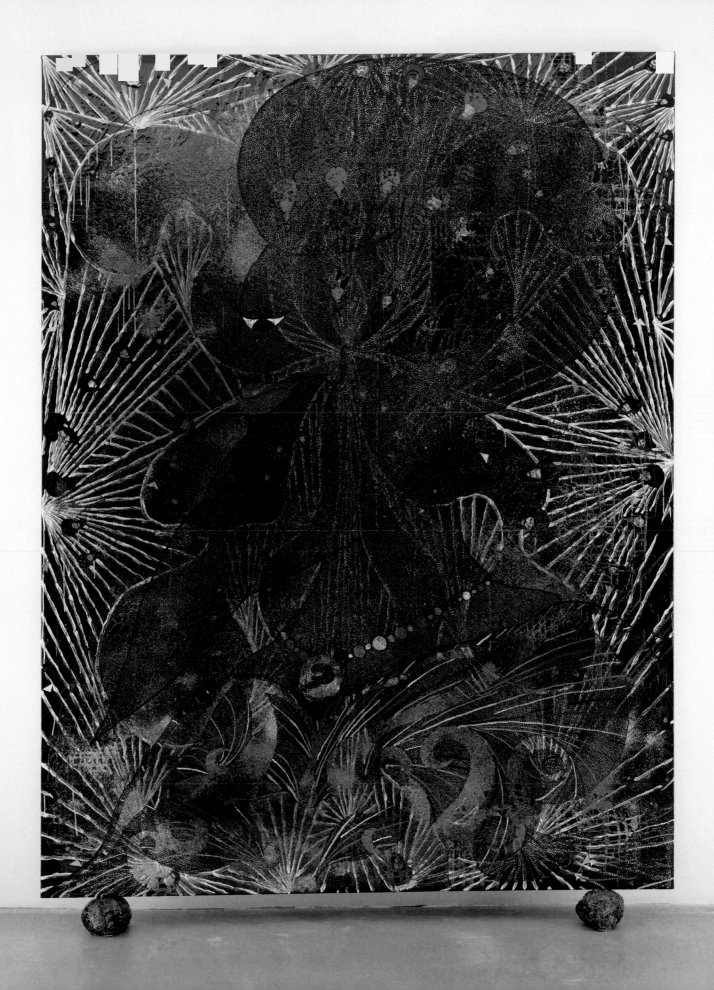

Afrovoid (London 18.4.97) 1997
Pencil on paper 56 x 76

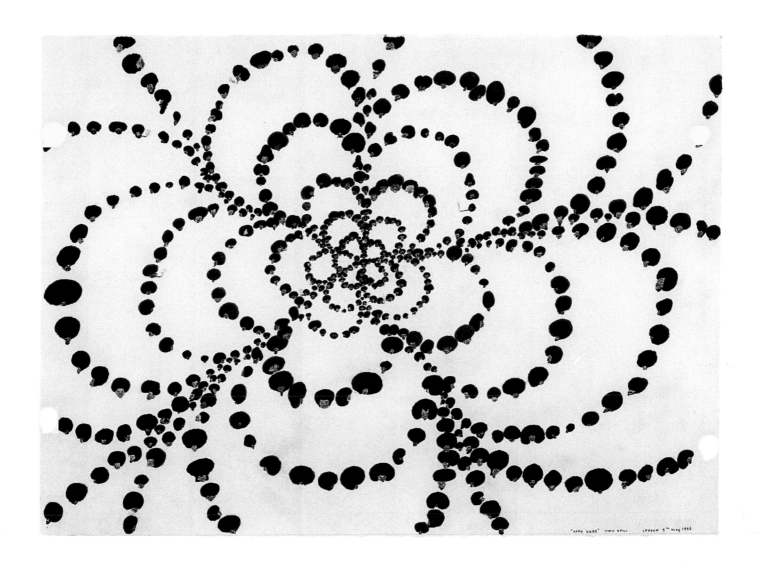

Afro Daze 1996
Pencil on paper 56 x 76

Albinos & Bros with Fros 1999
Pencil on paper 56 x 76

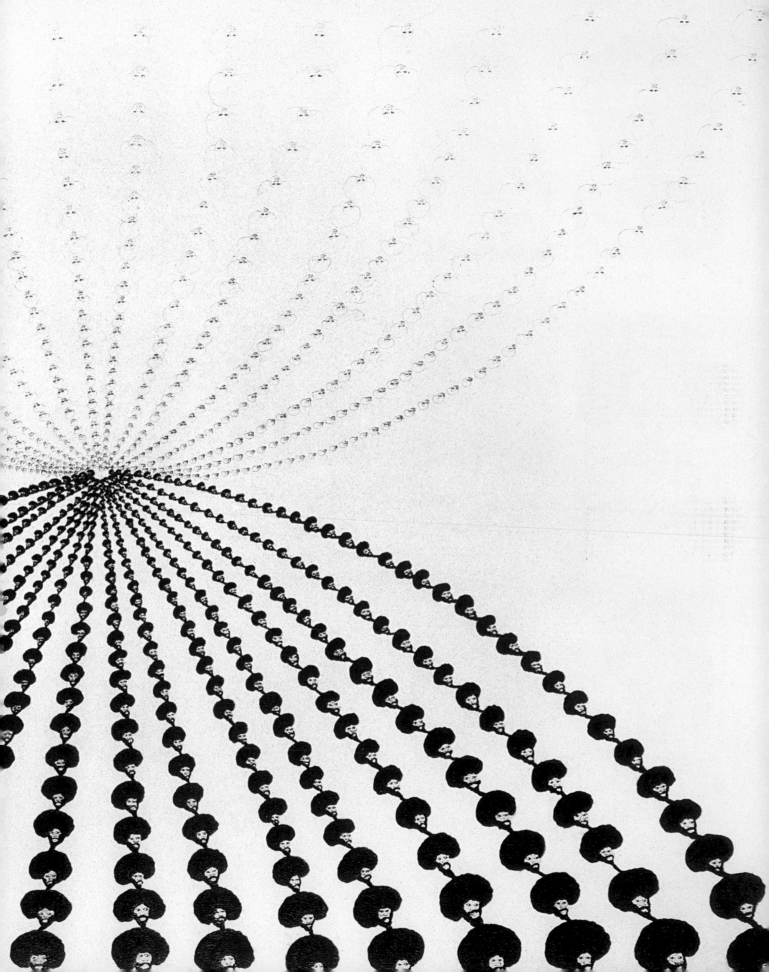

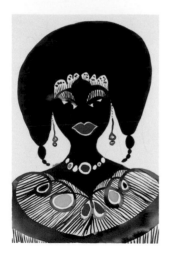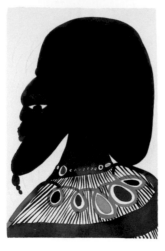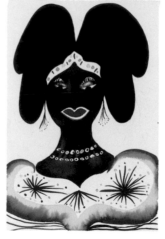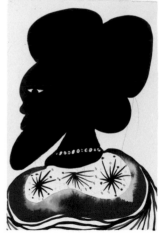
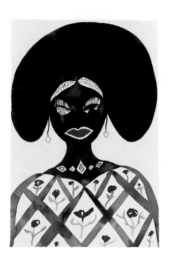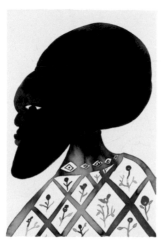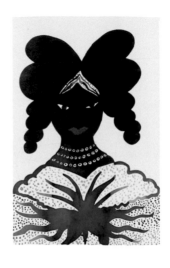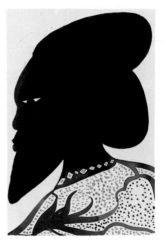
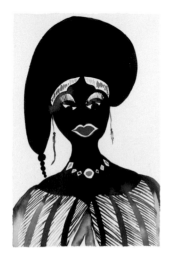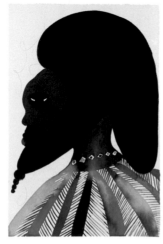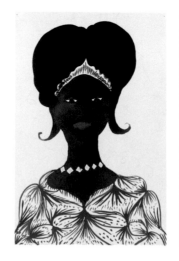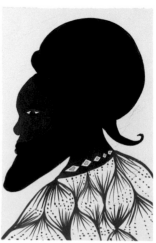

A selection from
Afromuses (Couple) 1995–2005
Watercolour and pencil on paper
Six diptychs, each part 24.3 x 15.7

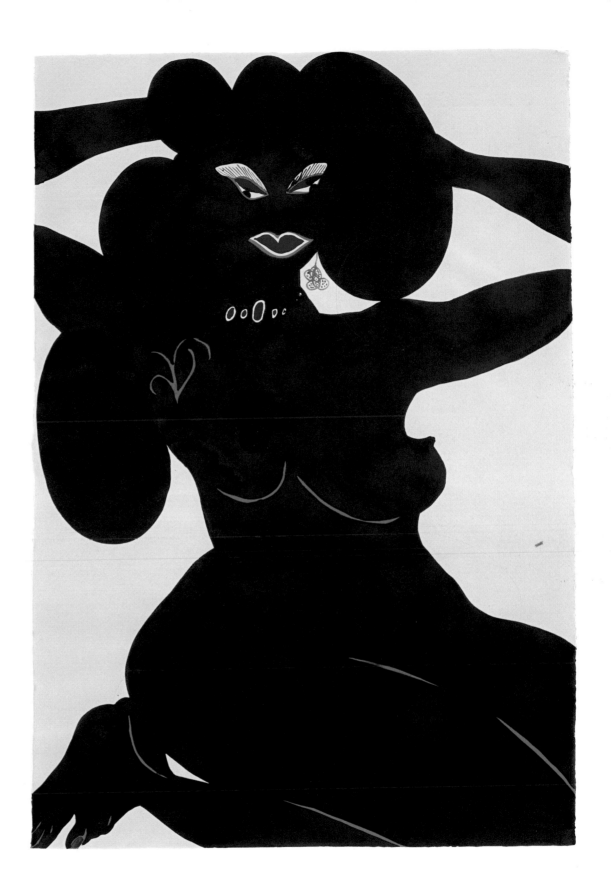

Untitled (Afronude) 2007
Watercolour and pencil on paper 63.2 x 43.5

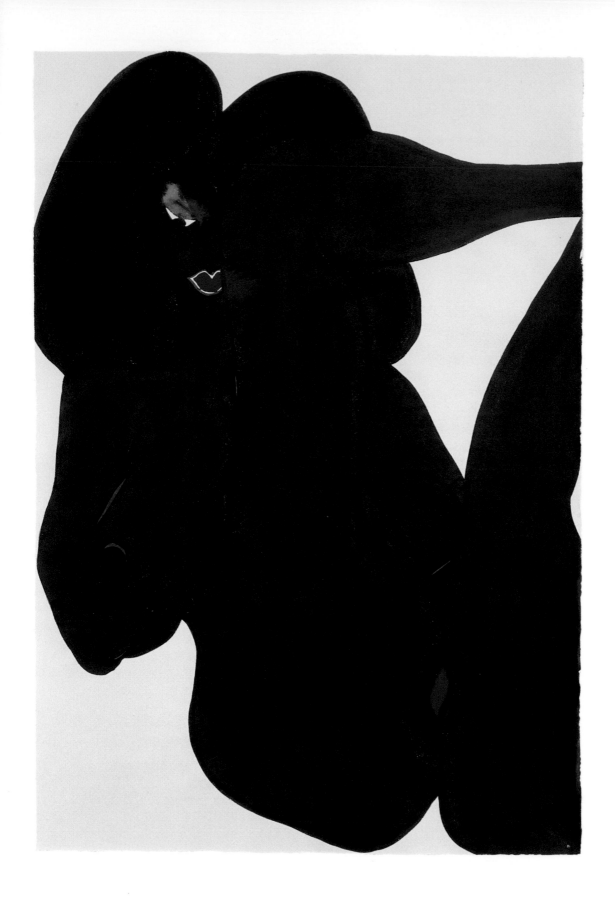

Untitled (Afronude) 2007
Watercolour and pencil on paper 63.2 x 43.5

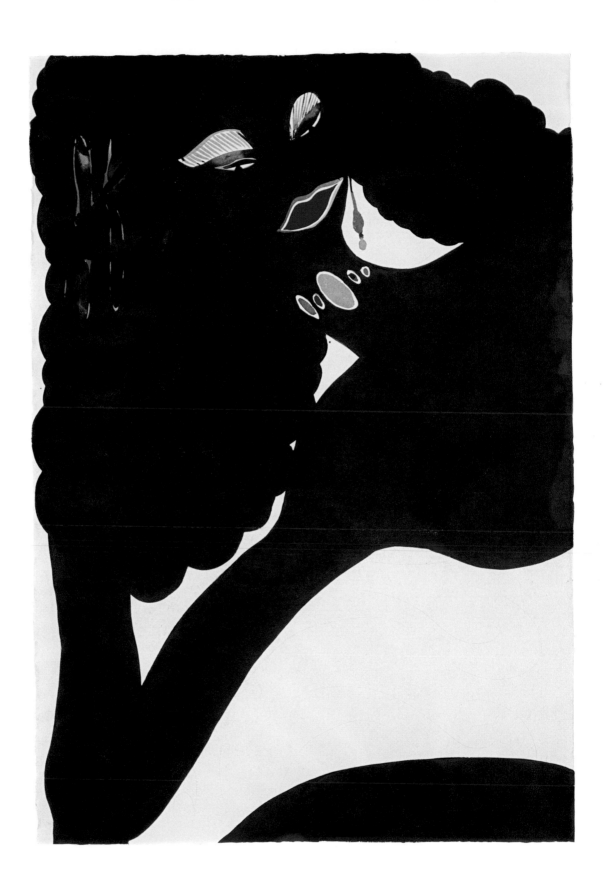

Untitled (Afronude) 2007
Watercolour and pencil on paper 63.2 x 43.5

A Gardener 2005
Watercolour and pencil on paper
Nine parts, each 24.3 x 15.7

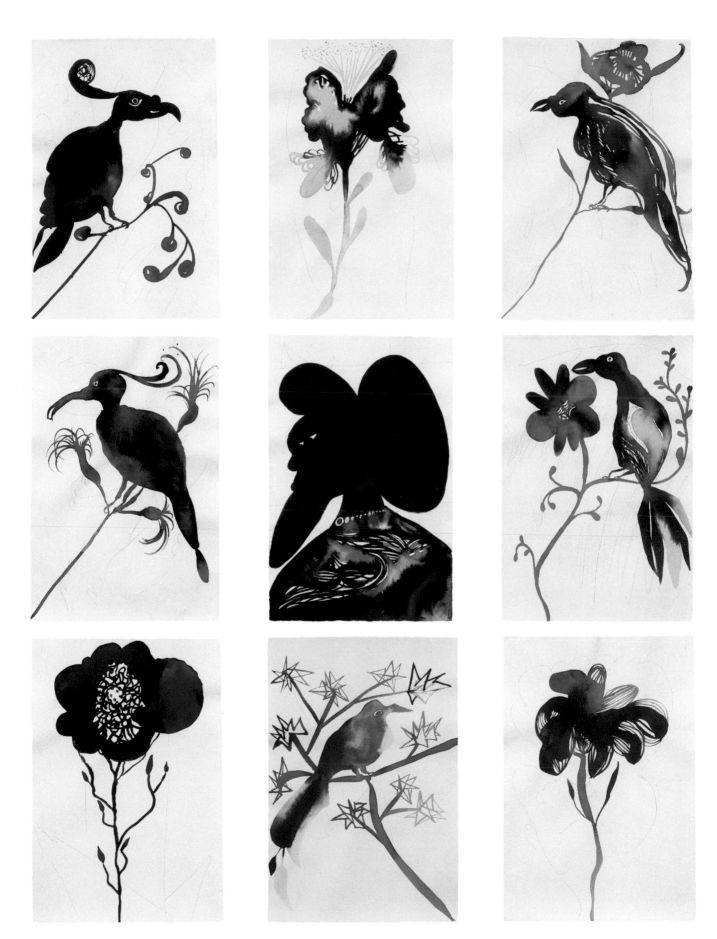

The Vexations and Pleasures of Colour: Chris Ofili's 'Afromuses' and the Dialectic of Painting

Okwui Enwezor

Black is the colour of my true love's hair[1]

There is a kind of radiance that emanates from the spreading liquidity of Chris Ofili's large series of intimate, small-scale watercolours, *Afromuses* 1995–2005, that makes them appear as if they are painted under sheets of glass rather than on sheets of textured aquarelle paper. Lit with streaks of brilliant jewel tones (aquamarine, coral, sapphire, emerald and jet), the watercolours appear to have seeped onto the surface of the paper from beneath. This contributes to the luminosity and translucence that lend the images an exquisiteness that a miniaturist would appreciate. Yet this seeming preciousness, even luxuriousness, belies an aesthetic disposition that goes beyond form and towards the content of the works: namely, the entanglement of painting with black figuration.

In large part, Ofili's work is figurative, interspersed with abstraction and landscape. Sometimes, as in the case of the paintings he showed in New York at David Zwirner gallery in autumn 2007, all three elements play an important role in the compositional network of figure and ground. Such combinations were initially developed and subsequently more forcefully elaborated in his paintings after a British Council travel grant afforded him the opportunity to undertake a research trip to Zimbabwe in 1992. Though Ofili's parents are Igbo from Nigeria, the trip was his first to Africa, and therefore holds a deep meaning for him, which can be seen in his subsequent paintings. Ofili visited numerous sites around the country including the Matobo National Park where he saw ancient cave paintings made of multiple dot patterns. During the six-week-long trip, he also toured the

FIGS. 18a/b
Selection of two from thirty
Untitled 1998
Watercolour and pencil on paper
Each 24 x 15

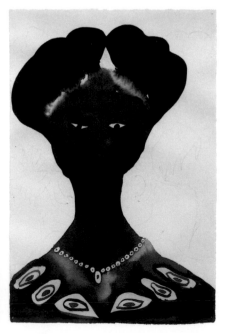

1.
This line comes from a song by the great American Jazz pianist and singer Nina Simone whose career spanned militant songs of social defiance, black empowerment, and subtle recastings of classical American song-book and standards. I use it partly to illuminate the recurring issues of colour and race in the work of artists of African descent, but also to suggest how broadly such issues have been articulated in representation as ways of figuring blackness in contemporary art and culture at large. I am also evoking this song as a link to Ofili's deep interest in music and to situate his work and ideas within a wider black artistic and cultural oeuvre.

2.
Ofili has suggested that the dotted lines and all-over patterns in his early paintings is a response to the trail of Elephants pissing on their dung to moisten and mark it. See Louisa Buck, 'Chris Ofili', *Artforum*, September 1997, pp.112–13.

3.
From afros to dreadlocks to cornrows, hair has been used in the art of diasporic Africans as a signifier accompanying the politics of race, identity, difference and black power. Its employment in Ofili's work resonates with other postmodern artistic strategies, particularly that of the African American conceptualist David Hammons, whose influence on Ofili has been enormous. In his sculptures, Hammons has made repeated use of hair procured from black barbershops in Harlem. During the 1980s he also began using decorated elephant dung as part of his sculptural production.

archaeological ruins of Great Zimbabwe, the ancient site of stone dwellings scattered around a vast area in the country. The African landscape and the traces of cultural remains that dot the site at Great Zimbabwe are especially resonant in an early painting of the period: *Painting with Shit on it* 1993 (p.24). Despite its overt scatological title, if one reads *Painting with Shit on it* closely, the association with landscape makes itself clear.[2] The outline of the painting is constructed like a grid. Onto its dark ground are painted thousands of fiery orange dots; geometric shapes in a lighter shade are dispersed across the painting, to which a clump of elephant dung is attached. The painting reads like an aerial view of a landscape. At the same time, it represents a perspective view of a map-like open space, whose cartographic marks remind one of the sites on which Great Zimbabwe sits.

Despite the fact that Ofili at this juncture was a neophyte to Africa, his emotional and spiritual entanglement with Africa as place is formally implied in his spatial perceptions of the continent. This formative trip left a profound impression on him, both in terms of the direction his paintings would take throughout the decade and the refinement of painterly space in his work during the middle part of this decade. Another important element of this trip to Zimbabwe was his discovery of elephant dung – of which he had his first close-up view, as it were, in the bush – as a crucial material for his art. Whatever the scatological symbolism the elephant dung may have held for him, what was most significant was the role the material came to play in his paintings: its metaphysical, conceptual and sculptural possibilities – elephant dung as a spiritual signifier of a connection to Africa, especially between nature and culture, between Great Zimbabwe and London.

Even if these associations and the binaries they evoke may retail clichés of Africa, they nevertheless provided him with an outlet to transform a material that would otherwise have had no redeeming artistic value and purpose into a powerful aesthetic symbol. All through the 1990s, Ofili would employ the dung, sourced from zoos, as a signature material. First, he used the pachyderm's generous and surprisingly resilient turd for sculpture, retaining the rounded shape as he found it and coating it with resin to giving it a consistency that resembles the packed-earth animal forms of the enigmatic *Boliw* sculptures found in Bamana shrines in Mali. The neo-Primitivist *Shithead* 1993 (p.23), sculpted from the dung, is a seminal piece in this regard, particularly in the fetishistic power it conveys. The sculpture takes on the character of a shrine piece, combining dung with strands of human dreadlocks,[3] and with human teeth that fill a gawping carapace in the form of a mouth, to create a work of tension and force. *Shithead* represents Ofili's first important development of figuration. And in it, he introduced the significance that a politics of blackness would hold in his work. In retrospect, that early gesture may strike one as polemically literal; this is not an easy work to love. But it is nevertheless a powerful statement; a clear signal of Ofili's position-taking in the then burgeoning cultural phenomenon of the Young British Artists.

While making *Shithead*, Ofili began incorporating rounded forms of elephant dung into the surface of the canvases. In this way, he commenced a deregulation of the connection between painting and flatness, seeing his work as a hybrid object that was not either/or, but neither/nor: not painting entirely and not sculpture exactly. The two were fused, but it was the idea of what painting – a medium mostly associated with powerful, male, white European artists – could be that was most at stake, as he worked at reformulating his own unique stance within it. Pressing elephant dung onto the surface of the paintings was one way of animating the environment of the pictorial plots he conceived. And the challenge did not end there. He also started employing the dung as balls decorated with coloured beads as supports for his paintings. This use of dung as material on which the paintings could stand, almost like mini pedestals, contributed to shifting the emphasis of the painting as a picture on the wall to a thing, an objectified image freed from the plane. By moving the support to the floor, a further hybridisation occurred; a positioning that links the horizontality of the floor with landscape.

The first seminal paintings such as *Painting with Shit on it*, *Popcorn Tits* 1995 and *Blind Popcorn* 1995 (pp.26 and 27) were pictorial essays on form (abstraction and figuration) and content (race, sex and identity), thus revealing the semantics of colour, abstraction, the body and landscape compositions. These early works also laid the ground that showed that his paintings, unlike those being made by his contemporaries at the time (including those by his slightly older friend Peter Doig), were not just vessels for an exploratory archaeology into formalism, but the beginning of a pictorial investigation that radically politicised the space of painting. Throughout this period, Ofili's critical debts to modernist painting of the post-war period such as Abstract Expressionism, colour-field painting and neo-expressionism was clear enough. But he was equally in tune with the self-consciously decorative attitude of 1970s painting. However, these concerns did not obscure his bold attempt to conceive a dialectic of painting that was at once formally heterogeneous and culturally specific. After all, he was formed during the rise of rap and hip-hop music and their counter-cultural and oppositional politics vis-à-vis the dominant culture. In addition, as a student at Chelsea School of Art and the Royal College of Art in the late 1980s and early 1990s, he was well aware of the critical influence of British cultural studies, and in tune with the writings of thinkers and theorists such as Stuart Hall, Paul Gilroy, Homi K. Bhabha and others at a time when Thatcherism was intent on policing black socialities and constraining ethnic subjectivities.

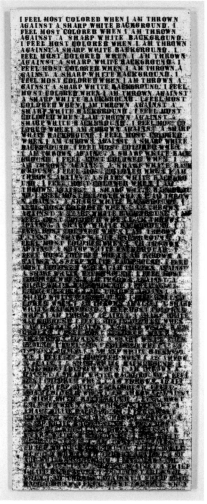

FIG. 19
Glenn Ligon
Untitled (I Feel Most Colored When I Am Thrown Against a Sharp White Background) 1990–1
Oilstick and gesso on panel 203.2 x 76.2

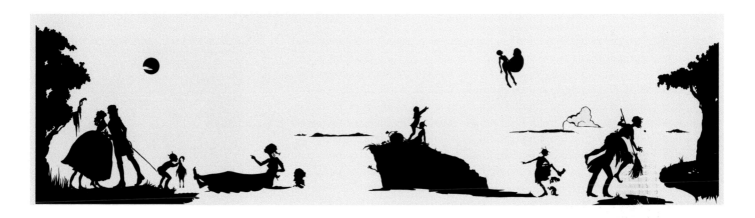

FIG. 20
Kara Walker
**Gone, An Historical Romance of
a Civil War as it Occurred between
the Dusky Thighs of One Young
Negress and Her Heart** 1994
Cut paper 457.2 x 1524

Artistically, however, it was in the direction of discourses of black figuration developed in the work of African American artists that Ofili's work turned. Observed from the vantage point of the historical moment when his first serious paintings entered the public domain, one could see how the works were partly rooted in the tradition of postmodern figurative painting in which the figure (namely, the black figure) depicted in the space of contemporary painting was employed to prise open a dialectical space between representation and cultural discourse. The precedents for this analysis of painting, figuration and representation, and its discursive development, were Robert Colescott, Jean-Michel Basquiat (his roughly drawn heads bear an uncanny resemblance to Ofili's *Shithead*) and Kerry James Marshall, amongst others. These artists, in remarkable ways, foregrounded the dialectical dimension and the aesthetic possibility of black figurative style. In so doing, they articulated its enmeshment with the problems of painting and representation.

Glenn Ligon would develop this issue in a more rigorous conceptual format in his stencilled text-based paintings by giving them a linguistic frame through the deployment of language as both material and discourse. Another important figure amongst this conceptualist strand is Adrian Piper, whose heterogeneous practices in photography, drawing and performance enunciated the problematic of the black figure in representation. Lorna Simpson would advance these ideas even further in keenly honed installations via photography, video and film, while the younger Kara Walker expanded them through the black silhouettes of her mural-scale paper cut-outs. More recently, the young Ghanaian British painter Lynette Yiadom Boakye presented her gallery of invented black female portraits. It is quite clear from the consistency of this analytical dimension in contemporary postmodern figuration that it is not only a part of Ofili's own development, but one he helped engender. Still, there remain marked differences in the formal stances of each of these artists' works.

Invisibility Blues:[4] Dialectics of Figurative and Subjective Blackness

Despite the differences, one way to unite the artists' approaches to blackness as a device of representation in painting is to examine the degree to which modes of appearance and visibility played a role in the conception of the works. I would argue that there are two operating discourses that can be gleaned from their work. The first is a discourse revolving around the public appearance of the black subject as it is engendered by the negativity of racism. This discourse and the response in artistic practice could be described as a relationship to figurative blackness. Adrian Piper's drawing, *Self Portrait Exaggerating my Negroid Features* 1980 is a case in point: here she deliberately distorts her self-representation in a mimicry of an appearance that may be understood as conventionally and authentically black (as if all peoples of African descent have identical physiognomic attributes). Another example is Robert Colescott's caricature paintings that draw on racist images of African Americans.

The second discourse addresses and articulates the problems of social visibility within cultural systems of representation (art, literature, media, cinema) that cloak blackness in invisibility through its negation in historical representations. This position attacks the symbols of invisibility, negation and social erasure through the framing of what I would designate as 'subjective blackness'. Glenn Ligon's stencilled text paintings are normally executed with viscous oilstick on white canvas, which creates a dense, tactile rendering that sets the letters in relief, the more to foreground the contrast, and therefore the tension, between figure and ground, whiteness and blackness. Works such as *Untitled* (*I am an Invisible Man*) 1991,[5] *Untitled* (*I Feel Most Colored When I am Thrown Against a Sharp White Ground*) 1990–1[6] and *Untitled* (*I'm Turning Into a Specter Before Your Very Eyes and I'm Going to Haunt You*) 1992, are painted in this way, and have a remarkable consistency in sharpening the way in which the works are seen as painting without detaching the texts from the ideas to which they refer. All the paintings deploy passages from American literary and media representations that either address figurations of black negation or examine possible dimensions of its subjective visibility.

Likewise, in *Twenty Questions* (*A Sampler*) 1988, an installation of four identical black and white photographs showing the head of a woman from the back, alongside six text panels, Lorna Simpson explored this zone of negation and negativity, of blackness as a social aporia in mainstream Western cultural discourse. The grounding of the image in sentences taken from everyday life – familiar vernacular forms of speechmaking that also read like aphoristic games – examines how black subjectivity is bound up in structures of negation. Ligon and Simpson thus employ the sententious as a discursive device to address how blackness is positioned on the scaffold of visualisation, visibility and invisibility.

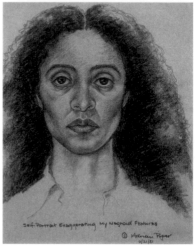

FIG. 21
Adrian Piper
**Self-Portrait Exaggerating
My Negroid Features** 1981
Pencil on paper 25.4 x 20.3

4.
In her seminal book *Invisibility Blues: From Pop to Theory and Back Again* (first published 1990), London 2008, feminist theorist Michelle Wallace employed the term to describe the condition of black women within mainstream feminism and also the invisibility of women in general under patriarchal society. I am using it here to map broader issues of social invisibility related to class, colour and race.

5.
The text that Ligon used for this painting is taken from Ralph Ellison's great novel *Invisible Man* (1952), which examined the cultural opacity to which African Americans were subjected in American society. The novel is also centred around a metaphysics of colour, especially blackness as a symbol of absence, invisibility and negativity.

6.
Here Ligon is using text from Zora Neale Hurston's, 'How it Feels to be Colored Me', *World Tomorrow*, no.11, May 1928, pp.215–16.

FIG. 22
Lorna Simpson
Twenty Questions (A Sampler) 1986
4 gelatin silver prints,
6 engraved plastic plaques
Photographs 64.8 each (framed diameter),
271.1 overall

7.
Morrison uses the phrase 'abiding whiteness' to describe American writing in which the rendering of whiteness is often made at the expense of blackness. My reading of Ofili's work and that of his contemporaries is not meant to suggest that their focus on interrogating the cultural viability of blackness seeks to do so at the expense of whiteness. As some of the artist's work shows, there is a complex negotiation between both culturalist and historicist notions of race and colour in representation to which artists and writers have ceaselessly returned. For further insight into Morrison's analysis, to which I have returned in several other texts that address the problematic of how artists in the 1990s have addressed race, see Toni Morrison, *Playing in the Dark: Whiteness and the Literary Imagination*, New York 1992.

8.
The exhibition, the first major survey of Ofili's work in a US museum, as well as the first comprehensive presentation of the watercolours, was organised by Thelma Golden and was on view from 27 April – 3 July 2005. See Thelma Golden (ed.), *Chris Ofili: Afro Muses, 1995–2005*, exh. cat., The Studio Museum in Harlem, New York 2005. The title of the show differs from that of the group of works displayed: *Afromuses*.

These issues, amongst so many others that were developed during the height of the decade of so-called identity and multicultural debates, are important starting points when thinking about Ofili's overall aesthetic programme. Lest it appear that I am making a case for what, to paraphrase Toni Morrison, could be called an 'abiding blackness'[7] in Ofili's work, and having raised the problematic of race and colour as a sign attaching to it, I shall also endeavour, in the latter part of the essay, to explore other discursive opportunities through the iconographic citations made by Ofili in *Afromuses*, where he draws from the work of West African photographers and the *sous verre* (under-glass) painting tradition of Senegal. These citations are important in situating his practice in a broader field of artistic debates.

A Luminous Blackness

In the spring of 2005, The Studio Museum in Harlem presented *Chris Ofili: Afro Muses, 1995–2005* (pp.58–64 and 79), a survey of 181 watercolours in washes of muted, bright and intense colours that lit up the galleries of the museum.[8] The images were notable not only for their luminosity and radiance, but also for Ofili's concise articulation of the subtle gradations and shifting tonalities and shades of 'blackness', which ran the gamut from warm kola-nut brown to deep chocolate and dense aubergine. Across this range of notions of blackness, it was possible to perceive colour as a complex descriptor of pigmentation, and therefore as both a cipher and sign for race and identity. But the intersection of the social ideas of colour and cultural constructions of race also opened themselves up to Ofili's analysis of the problematics in painting and representation.

The works, which spanned a period of intense pictorial investigation, revealed a deliberative and ruminative style of working. And despite the unpredictability and instability of the medium, each piece was flawless in execution, with no visible mistakes or corrections. What the exhibition showed as well, was an artist who appeared to have submitted himself entirely to the pleasure of painting as a kind of secret, sensual, private experience. Painted over a decade, at a point when Ofili had established himself as a high-ranking artist of his generation, the watercolours almost entirely comprised portraits of women and men, interspersed with a smattering of floral still lifes and nature studies of exotic birds.

The large compendium of portraits, rendered either frontally or in profile, was organised in grids, salon-style, according to a representational system defined by the artist and the curator Thelma Golden. Though painted to delineate an intensely stylised blackness, the images also suggested individuality, mostly through the outfits of the figures. The images had two separate unifying compositional elements. The first established the gendered lines each portrait inhabited: the elongated necks of the female characters, which gave them a certain hauteur and grace, and the pointy, sometimes braided beards of the

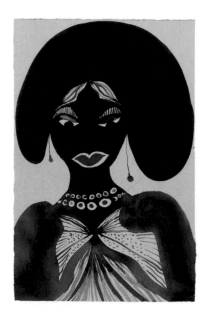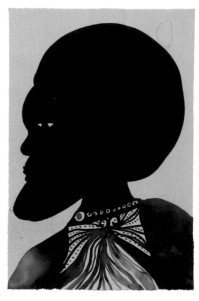

FIG. 23
Afromuses (Couple) 1995–2005
Watercolour and pencil on paper
Diptych, each part 24.3 x 15.7

male figures, which imparted a dandified air. The second element was the shared pattern of soft, rounded afro hairstyles, though the elaborate designs of the women's hair are more extensive, with greater variety of treatment and opulent styles. There is a certain orientalist flavour to the images that gives them a sophisticated exoticism. Attached to the female figures' coiffures, just below the hairline, are diversely designed diadems, lending the women a grand sense of sovereignty. The cloud-like mounds of soft afro hairstyles implicate the notion of hair as a political signifier borrowed from the countercultural moment of the 'black is beautiful' 1960s. Here then, hair is not merely a motif, but, like language itself, serves important aesthetic and signifying functions. Moreover, the treatment of the hairstyles, which suggest masculine and feminine archetypes, tugged at the deliberate and explicit notions of afrocentricity that have played an important iconographical role in Ofili's representational repertoire. Focus on race, identity, gender, afrocentric iconography, as well as questions of black masculinity and femininity – and the war of position that surrounds them, especially in feminist critiques of misogyny in hip-hop lyrics and imagery – have been a crucial and critical part of Ofili's archeology of black figuration. However, such a focus turns less on a position of objectified and essentialist blackness than on an attempt at the aesthetic normalisation of blackness.

There is a matter-of-factness to Ofili's usage of blackness that does not make it easily reducible to race alone. Rather, he transforms the coded mark of colour and the problematic of race as a measure of the challenge presented by painting and representation. As the show's curator Thelma Golden perspicaciously remarked in her analysis of the *Afromuses*: 'the project of picturing blackness …

FIG. 24
Installation view, **Afro Muses 1995–2005**,
The Studio Museum in Harlem, New York,
2005

9.
Thelma Golden, 'She and He' in ibid., p.15.
10.
Ibid., p.15.

is a preoccupation … neither stemming from a desire to document nor as a corrective impulse, it is a way to push new notions of race and culture'.[9] Ofili's pictorial references to blackness might sometimes prove discomfiting for viewers unaccustomed to his direct mode of painterly address. However, sustained engagement with the paintings begins to reveal the subtlety and complexity of the task of such representation. Golden explores this issue, writing that: 'In his artwork Ofili does not perform or document racial types, he creates them. In this imagined space, Ofili presents the division between art and life as the space between the truth of experience and the fiction of the painted surface.'[10] This claim of a tension between experience, fiction and painting is a remarkable insight into Ofili's artistic motivation, especially in his attempt to subvert the easy iconography of blackness as a social pathology.

The *Afromuses* exist at a remove from any configuration in which blackness plays the role of a cultural protagonist or explains a racial dialectic. Painting imaginary figures, as he has done in works such as the *Captain Shit* series, rather than employing direct documentary references, seems to be a strategy deployed in order to move the viewer away from any over-determined reading of the images. Thus the grouping of the watercolours typically alluded to a narrative of relationships amongst characters united more by class and gender than by ethnicity and race. The relationship between some images, for example, foregrounded modes of courtship, or gender-specific positions. In the organisational chart of roles, positions are sometimes subtly subverted. For instance, in groupings such as *Harem 1*, *Harem 2*, *Harem 3* and *Harem 4*, a grid of nine images alternated between eight female portraits with a single male portrait in the middle, or the reverse, eight male portraits surrounding a single female. This arrangement suggested the idea of equality between male and female desire.

Other arrangements, such as *The Suitors* and *The Unkissed*, separated the men and women in defined roles of courtship: with men portrayed as suitors and females as unkissed. The grouping was organised as two separate horizontal lines, with five bearded males on top, painted in profile, all facing left, and five females at the bottom, depicted frontally, all facing the viewer. The female figures in *The Unkissed* suggest a kind of wholesome, virginal state. Ofili annotates this by leaving the lips unpainted, thus making the unadorned lips stand for a yet-to-be fulfilled desire. Other pairings, for instance *Couples* and *The Gardener*, are introduced into the narrative of gendered typologies to expand the possible organisational flowchart (pp.58 and 63).

Given the wide variety of available images and possible arrangements, this body of work could no longer be perceived as a minor preoccupation in Ofili's oeuvre, but as a practice that over time had become a major force in his critical thinking around the problem of painting, portraiture and black representation. An important question that the achievement of the watercolours prompts, then, is whether it is

possible to separate different aspects of Ofili's practice – painting, watercolours, drawing, printmaking – into major and minor forms, since it is clear that he is not only thoroughly proficient in all these different spheres, but that each of these elements is continuously unfolded and explored in some fashion in all his work. The watercolours therefore cannot be treated as studies for the paintings, a programme of working that would otherwise affirm the priority of painting. As Golden has remarked: 'While some of the works were the starting point for larger paintings, overall the watercolours are not created strictly as sketches or studies, but as fully realised works of their own.'[11]

Even in the watercolours, Ofili made a conscious decision to expose the drawing within the portraits, leaving unerased on the surfaces of the paper curling patterns, curving, swirling lines that run through the portraits. This is further underscored by the way in which he made the decorative motifs adorning the garments of the figures in the watercolours a focal point of all the images. The motifs, which range from West African tie-dye to floral and geometric textile patterns, are like fields of luminescence, and are treated not just as decorative adornment but as a kind of pictorial archaeology of patterns and invented forms that are further unveiled in the paintings.

Between Frames: Painting and the Crisis of Subjectivity

While a survey of this rich body of work permits a focus on Ofili's pictorial reflection on painting, the issue of form is never subordinated to content. And vice versa. In general, paint in Ofili's work, and its colours in particular, is not an inert, neutral material, but carries subjective and subjunctive powers of suggestion. Quite simply, Ofili has never sought to abandon the idea that notions of race, identity, portraiture and black subjectivity represent important philosophical vectors in his powerful figurative art. As if this conjunction between figuration and representation were not already visibly defined in the 181 watercolours, still playing in the background was the public controversy surrounding his painting *The Holy Virgin Mary* 1996 (p.33), shown in his last major museum exhibition (if one excludes various permanent collection displays of his paintings in US museums) at the Brooklyn Museum in 1999.[12] If the public fracas that ensued over the display of his painting of a black Madonna adorned with elephant dung aroused interest during the exhibition *Afro Muses*, it put in relief the fact that the exhibition was Ofili's first US museum survey, and marked an important return to the institutional spotlight in the country after a six-year hiatus.

To those familiar with Ofili's elaborately worked, jewel-like paintings, his formal objectives as an artist seemed very well established in the large-scale paintings he produced during the 1990s. Dramatically propped up on decorated elephant

11.
Ibid., p.13.

12.
On the controversy surrounding *Sensation*, see Judith Nesbitt in this volume, p.16.

13.
A mid-career survey of Ofili's paintings at the Serpentine Gallery, London in 1998, aroused a different sort of critique owing to his citation of hip-hop and usage of porn images as collage elements in some of his work. For such a critique, see Coco Fusco, 'Captain Shit and Other Allegories of Black Stardom: The Work of Chris Ofili', *Nka: Journal Of Contemporary African Art*, no.10, Spring/Summer 1999.

14.
The Upper Room was first presented at the Victoria Miro Gallery, London in 2002.

15.
For a discussion of the critical implications of the *Within Reach* installation, see my essay 'Shattering the Mirror of Tradition: Chris Ofili's: Triumph of Painting at the 50th Venice Biennale', in *Chris Ofili*, New York 2009.

16.
The exhibition of this body of work took place in Berlin at Contemporary Fine Arts in the winter of 2005 and at kestnergesellschaft, Hanover, in the summer of 2006. The title of the paintings was a reference to Der Blaue Reiter, a group of German avant-garde painters of the early twentieth century.

dung balls, and leant against walls, the paintings radiated a forceful aura. Compounded by the public debates that have sometimes accompanied the display of these paintings/objects in galleries and museums,[13] his work may have appeared set in place, congealed in the aspic of familiar forms and visual tropes. In fact, throughout the 1990s, certain critiques of Ofili's work tended to lapse into overdetermined readings of the manifestation of blackness – whether appropriated from hip-hop media or porn magazines – and offered a reductive view of his art by routinely claiming as part of his ideas the baggage and clichés attaching to the excesses of multiculturalism. However, by the turn of this decade, as artists shaped by the important debates initiated by multiculturalism, postmodernism, feminism, queer and cultural studies matured, the nature of their work was also transformed into more coded forms, into highly nuanced modes of delivery and critical address.

It is in the juncture of this transformation that the watercolours may make the most sense ontologically, in terms of the links to Ofili's other practices. The prevailing idea conveyed in the *Afromuses* especially, was the feeling that his work had become increasingly introspective and intensely reflective. The scope of his ideas as an artist became more complex, in terms of artistic agenda, objective and ambition. Painting was not only a means through which exquisitely executed allegories could be kneaded into stand-alone vessels of aesthetic appreciation, but the formats he adopted – drawing, printmaking, sculpture, watercolour, painting – pushed the development of narrative cycles that sought to depict broader epistemological concerns and cosmological themes.

A breakthrough moment of this development appeared in *The Upper Room* 1999–2002,[14] a cycle of thirteen paintings in which the Rhesus monkey served as the iconic image in a sequence of panels installed in a chapel-like architecture especially designed by the British-Ghanaian architect David Adjaye (pp.80–95). The figure of the monkey was a reference to Hanuman the deity, who in *Ramayana*, the Hindu epic, led an army of monkeys into battle against the demonic Ravana. A year later, Ofili would call again on Adjaye to collaborate in an even more ambitious installation, *Within Reach* 2003, at the 50th Venice Biennale. Like *The Upper Room*, the Venice installation reflected a religious themed narrative, in this case through the idea of an Edenic African landscape in which a black love story between an African Adam and Eve is narrated.[15] The quest to move into new territories of painting did not end with these cycles of paintings housed in immersive devotional environments. In late 2005, Ofili again shifted the orientation of his painterly development in the *Blue Rider*,[16] a series of almost monochromatic deep-indigo canvases laced with splashes of silver leaf, which depict mythological scenes, female nudes, figures on horseback, and musicians (see pp.120–7). However, a prominent element in the *Blue Rider* suite are images and sculptures of crouching, defecating figures, which Ofili borrowed from a similarly defecating

folk figure, the *Caganer*, often found in Catalan nativity scenes.[17] These images from the *Blue Rider* series were later extended in the David Zwirner gallery exhibition in which Ofili continued the chromatic saturation of indigo in scenes of searing agony depicting lynched black male figures. These fugue-like paintings evinced a fascination with religiosity that has been part of Ofili's work from the beginning, in which he addressed ideas of the profane, especially in *The Holy Virgin Mary*, with her bared breast.

But the most important element introduced in this new body of work is the break Ofili made from the signature elephant-dung paintings. The *Blue Rider* series brought to a conclusion the decade of practice that was engendered by his first encounter with Africa. These paintings are at once works of transition and the site for the renewal of the classical idea of painting as a picture fixed on the wall. They proposed an assertive closure to the idea of painting as a three-dimensional object, a motivation first established by detaching it from the wall and thus summoning a rereading of, and a resistance to, Greenbergian notions of flatness as the ontological space of painting. Ofili's propped-up paintings, which dazzled with their kaleidoscopic and optically challenging layers of colour, clotted with clumps of dung, were both paintings in the traditional sense and objects detached from that tradition. To resolve this tension, Ofili abandoned the floor and moved his large paintings back to the wall. The *Blue Rider* series thus became a moment for a break with the in-betweenness of painting that had been at the heart of his critical enterprise.[18] The conclusive return to the wall would occur a year later, in a new body of work, *Devil's Pie* 2007. At this point, the flatness of painting became a fascinating instrument for articulating the artificiality of the flat plane.[19]

In that sense, the gathering of the small-scale watercolours, hung salon-style at The Studio Museum in Harlem in 2005, presaged the direction that Ofili's work would decisively take in late 2005 and into 2006.[20] It may also have been an attempt to reconsider the tension between minor and major forms. But close observation of the watercolours would show that far from representing an opposition between the canonical stature of painting and less elevated forms such as drawing and watercolour, the works were demonstrations of Ofili's technical facility with the quick-drying medium, and of their centrality in his articulation of what the art-historian Yves Alain Bois calls 'painting as model'[21] – painting as a tool for a host of theoretical and formal propositions. Given Ofili's continuous, uninterrupted production of the watercolours alongside the slow production of paintings, it is quite possible that painting, watercolour and drawing represent three inseparable critical models, allowing Ofili, as Bois would argue, to think of painting not necessarily in its definitive form as a wholly autonomous medium, but as part of a broader repertoire of forms, representations, images and strategies. In this sense, painting is for Ofili a mode that brings together a whole host of cognitive, inventive, imaginative and discursive relations.

17.
Even though, by the time of this exhibition in Berlin and Hanover, Ofili had abandoned the elephant dung, his fascination with shit was made even more explicit in the paintings and sculptures which borrowed the emblem of defecation from the *Caganer*. For further discussion of the history of the *Caganer*, see Carolina Grau, 'The Caganer' in *Chris Ofili: The Blue Rider Extended Remix*, exh. cat., kestnergesellschaft, Hanover, 2006, p.13.

18.
Perhaps this break with the notion of painting as sculpture/object was made possible with Ofili's insistent turn towards the traditional format of figurative bronze sculpture. The conceptual conciseness of the paintings supported on elephant dung would have become muddled had the paintings and sculptures maintained the same positioning on the floor. It therefore strikes me that Ofili at this point was making his way back to the classical divisions of disciplines in which the sculpture occupied the floor as a three-dimensional form, and painting returned to the wall as a two-dimensional plane.

19.
This was directly articulated through the fluid and sinuous lines of saturated colours in the new paintings he showed at David Zwirner gallery in the autumn of 2007.

20.
It should be noted that over the years, Ofili had often shown flat works hung on or painted onto the wall rather than exclusively standing them on the floor.

21.
See Yves-Alain Bois, *Painting as Model*, Cambridge, MA 1990.

22.
For a full discussion of the theoretical dimension of painting, and the explication of its models, see Bois, pp.245–57. Of course, Bois's discussion of painting is predicated on European and American modernism, and does not address, as I have in relation to the works of African and African American artists, the disposition of painting towards engaging acts of social erasure that transforms the surface of painting into an active pictorial and discursive operation.

FIG. 25
Salla Casset
La Militante du SFIO 1952
Photograph

FIG. 26
Babacar Lo
Woman with Libidor Date unknown
Sous-verre (or reverse-glass) painting 33 x 48

Bois offers four critical imperatives of painting, which he designates as its perceptive, technical, symbolic and strategic models.[22] In reading Ofili's work, the four models can be collapsed into two groups. In the first, the perceptive and technical models, an outline of black figuration is put forth, the more to reflect technical competence, but also to introduce the notion of the real in terms of the perceptive visualisation of blackness. The second aspect, the symbolic and strategic models, unveils important attributes in Ofili's practice, essential to the analysis of his work: namely, the imbrication of the black subjects of painting and the canons of art.

Citation and Pictorial Models

All of Ofili's work starts with one fundamental premise: an inquiry into the pictorial. To admit this much is also to concede that the pictorial in his work is much more than representation; it is about representativeness. We can observe this positioning as a direct result of the role that pictorial citation plays in his work. *Afromuses* is a good place to begin in understanding how Ofili's work cites the pictorial language of the modern African image repertoire, especially the work of West African photographers such as Salla Casset, Mama Casset, Meissa Gaye and Seydou Keïta. A second important reference, in terms of visual effects and scale, is to the Senegalese *sous verre* painting tradition.[23] As well as using motifs (such as flowers, birds and geometric designs) that are part of the *sous verre* representational repertoire, Ofili also directly references, in the imaginary portraits, the opulent *sous verre* portraits of Peul women, with their luxuriant hair, jewels, hennaed lips, dramatic make-up and elaborately configured head scarves (such as in the work of the contemporary painter Germaine Gaye or the more classical portraits of Babacar Lo). These attributes can also be found in the photographs of Salla and Mama Casset, Meissa Gaye and most notably Keïta. The last portion of this essay is therefore devoted to an examination of this intersection between 1940s and 1950s West African photographic studio portraits and Ofili's *Afromuses*.

The intersection, surprisingly, is not remarked on in the available literature on *Afromuses*. Different critics writing on this body of work have thus far made little connection to these pictorial practices that are well known in West Africa. Golden, in her essay on the watercolours, does hint at it, but without explicitly connecting them. For instance, she writes about the watercolours: 'Their small size typically and appropriately demanded intimate viewing, and are often hung to enhance this personal, and even devotional quality. They functioned in some spaces almost like portrait photographs; like intense someones peering at you from the wall.'[24] In this way, Golden places these works within an economy of visual production and circulation. Similarly, the photographs and religious icons, like the way the studio portraits of the photographers were employed in transactions connecting likeness to persons; or in the case of *sous verre*, linking portrayal to Sufi saints and Senegalese holy men could be understood as part of the visual economy of pictorial signs.

In the sumptuous compositions of Gaye, Mama and Salla Casset and Keïta and the flat, graphic rendering of the *sous verre* paintings, a host of visual codes are deployed. Two portraits by Salla Casset, *La Militante du SFIO* 1952 and *Driyanké* 1950, show the undeniable influence of these photographic portraits on Ofili's images. The drawing style in which he positions the subjects either diagonally or frontally in *Afromuses* closely matches the usage of such compositional techniques by the photographers to accentuate particular aspects of the women portrayed in their work. From the elaborately braided hair and the gold jewellery attached at the base of the forehead, to the makeup, the patterns and cut of the dress, seductively arranged to slip slightly off the shoulder, the affinities with *Afromuses* are not merely suggested but show the clear attention he has paid to the pictorial styles of the portrait photographs. The correspondences with, or as I argue, citations of, the decorum, poses, fashion and physiognomy celebrated in the West African studio portraits are representative of elements of African style, particularly as they are signified in the personal, as well as social, expressions of Muslim women in Senegal and Mali.

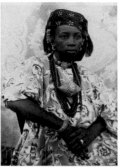

The most significant of these citations can be found in the sprawling oeuvre of Keïta, whose masterful, carefully composed and modulated black and white studio portraits from the late 1940s to the mid-1950s have become classics of a sensuously worked aesthetic of social grace. Keïta's portraits reveal the type of regal deportment that lend the images in *Afromuses* their allure. Like Ofili, he gave as much attention to the decorative as to the affective. Keïta catered to the extremes of the social composition of his native Bamako: from working-class traders and office clerks to would-be dandies and young coquettes; from colonial functionaries to the emerging westernised haute bourgeoisie; from grande dames to wealthy merchants. Through the layering of patterns, from backdrop to clothing, lighting to make-up, jewellery to hair, he produced fantasies of Africanity that remain unrivalled both in compositional inventiveness and aesthetic distinctiveness.

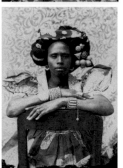

There is an untitled portrait of a young Peul woman – evidently wealthy and self-assured – whose directness is as engaging in its simplicity as in the opulence it lovingly celebrates, and which is reminiscent of some of Ofili's images. In the picture, the woman is seated and facing the viewer frontally, with a fixed, slightly detached look in her eyes. Her strategically placed arms, resting against the back of a simple wooden chair in order to display the gold jewellery on her wrists and tapered fingers, sweep upwards to the batwing-like sleeves of her stiff dress, and finally to the softly braided hair, which is partially covered with a floral scarf, with even more gold jewellery attached to the hair. If we fix attention on this portrait, or on those of the other strikingly beautiful women and princely men who populate Keïta's pictures, correspondences between these images and Ofili's accumulate a lexicon of signs denoting dimensions of black figuration. However, Ofili's work, while referencing these earlier portraits, does not overly depend on them. He in

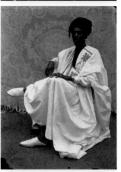

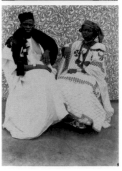

FIGS. 27a–d
Seydou Keïta
Four **Untitled** 1952–7
Gelatin silver prints

23.
According to Elizabeth Harney, the *sous verre* painting technique was introduced to Senegal in the late nineteenth century by wealthy Senegalese Muslim merchants who had first seen them on visits to Islamic shrines in the cities of Morocco such as Fez, Marrakech and Rabat. Their use was initially limited to the production of devotional images of Muslim saints and Sufi religious leaders in Senegal, but increasingly it was discovered by contemporary artists, who later put the technique to diverse uses. See Elizabeth Harney, *In Senghor's Shadow: Art, Politics, and the Avant-garde in Senegal, 1960–1995*, Durham 2004, pp.180–9.

24.
Golden, 'She and He', p.11.

25.
Ibid., p.13.

26.
Harney, *In Senghor's Shadow*, p.180.

27.
Darby English, *How To See a Work of Art in Total Darkness*, Cambridge, MA 2007, p.1.

fact extends them by adding new elements and references. As Golden argues, Ofili's work flows from a diversity of sources, an 'arsenal of references [that] includes figures from religion to popular culture'.[25] These references also evoke the transactions that occur within the *sous verre* painting tradition, which similarly draws from religion and popular culture. Art historian Elizabeth Harney has shown how the images of *sous verre* are part of the complex sphere of visual and popular culture in Senegal, oscillating between the economy of the 'tourist market' and 'the interest shown in it by academy-trained artists'.[26]

My interest in drawing parallels between Ofili's work and these practices, and the traditions of image-making to which they are connected, is not an attempt to establish a pictorial genealogy for him. Nor is it aimed at excavating his critical debts. Rather, I am interested in the diverse economy of black figurative styles, their aesthetic as well as social functions, and what they may tell us about the larger geography of colour, race, identity, representation and their enmeshment in contemporary painting as signs or as signifiers of certain pictorial models. If Ofili's work is bound up with the exploration of the artistic nexus that links these ideas to the politics of visibility and invisibility, figurative and subjective blackness, the task of the *sous verre* paintings and the studio photographs is much more circumscribed by their structures of production and systems of circulation in West Africa. The figurative styles perceived through *sous verre* painting and studio photography are localised in the meaning they produce, and specific in the signs they deploy. Ofili's *Afromuses* add to this fund of images and the aesthetic knowledge they have accrued. In this way, he reminds us that the critical task of painting, especially when it tackles the subject of black figuration, is about far more than representation as such, or the vexations of painting at large. Critical practices such as Ofili's, despite their grounding in classical methods and formal systems of representation like figuration, are equally about formulating theories of the specificity of painting as model, and about what inhabits the space of painting.

The point, then, might be to inquire, as Darby English so eloquently does in his important work on the presence of blackness in art: 'how to see a work of art in total darkness?' To this query, he responds: 'One cannot, of course, except in the most extraordinary circumstances, such as when darkness itself forms the condition of the work's visibility.'[27] Beyond the celebratory, pleasurable dimension of *Afromuses*, English's point strikes me, even if unacknowledged by Ofili, as partially the task of this body of work. At any rate, throughout his career Ofili has consciously inscribed this dialectic between form and content into the substance of his oeuvre, but not, as some may suppose, as an investment in appropriating the crisis of black subjectivity. *Afromuses* represents a kind of double-move that shows us how the vexations of painting in relation to black figuration, and the pleasures of colour as the exploration of its profound depth, are not binary systems, but a strategic and perceptive meshing of the two.

Selection of twelve from thirty
Untitled 1998
Watercolour and pencil on paper
Each 24 x 15

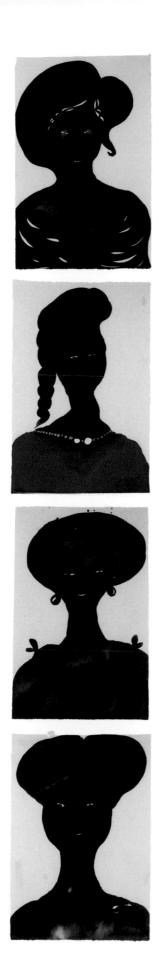
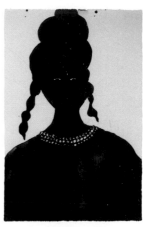
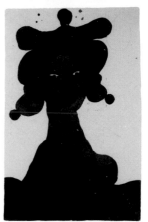
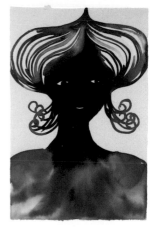
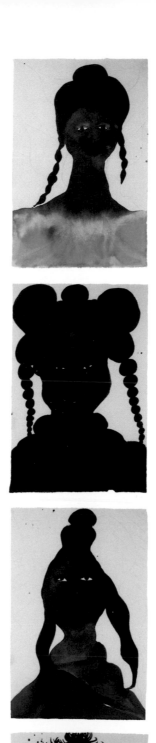
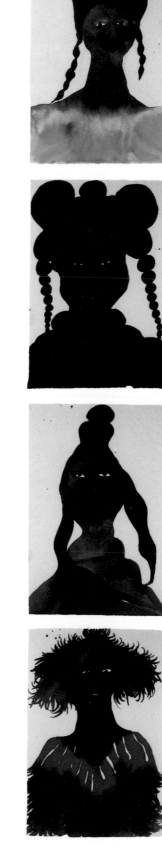
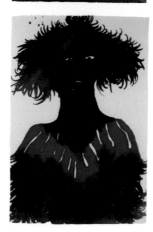
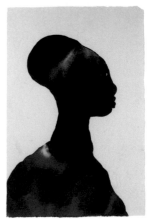

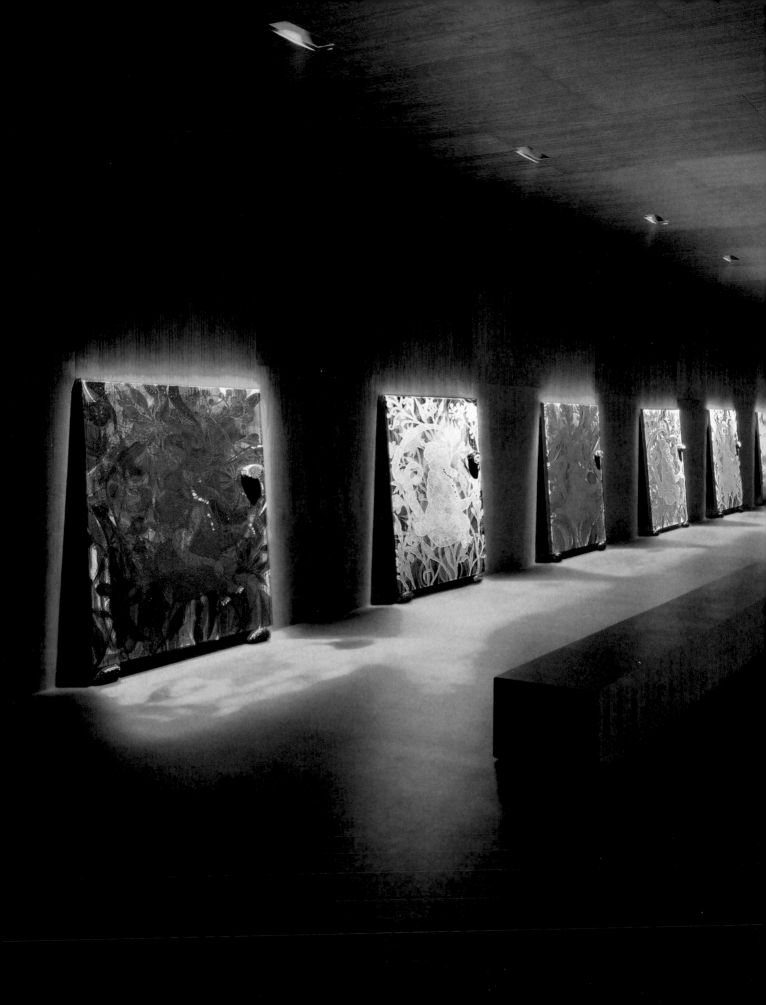

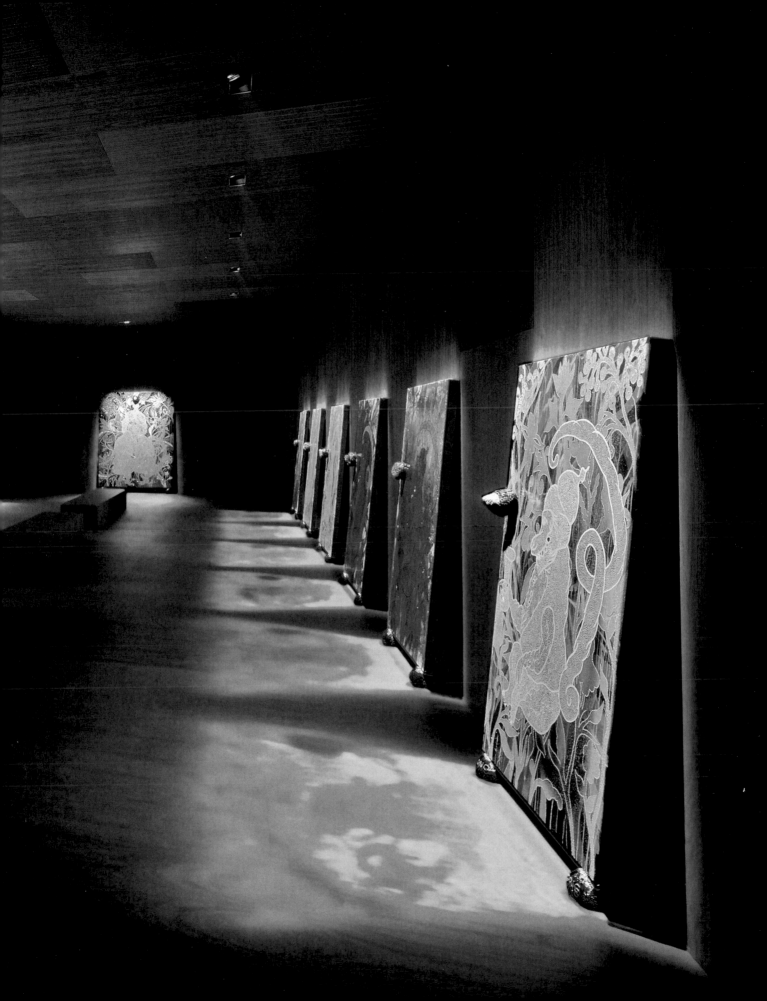

The Upper Room 1999–2002
Installation of thirteen paintings

Previous page
Installation at Tate Britain, 2005

Paintings in order of illustration
Mono Oro 1999–2002
Oil, acrylic, ink, gold leaf, polyester resin,
glitter, map pins and elephant dung
on linen 243.8 x 182.8

Mono Morado 1999–2002
Oil, pencil, polyester resin, glitter, map pins
and elephant dung on linen 182.8 x 121.9

Mono Blanco 1999–2002
Oil, acrylic, pencil, polyester resin,
glitter, map pins and elephant dung
on linen 182.8 x 121.9

Mono Rojo 1999–2002
Oil, ink, polyester resin, glitter, map pins
and elephant dung on linen 182.8 x 121.9

Mono Rosa 1999–2002
Oil, pencil, polyester resin, glitter, map pins
and elephant dung on linen 182.8 x 121.9

Mono Turquesa 1999–2002
Oil, acrylic, pencil, polyester resin,
glitter, map pins and elephant dung
on linen 182.8 x 121.9

Mono Amarillo 1999–2002
Oil, ink, polyester resin, glitter, map pins
and elephant dung on linen 182.8 x 121.9

Mono Marron 1999–2002
Oil, ink, polyester resin, glitter, map pins
and elephant dung on linen 182.8 x 121.9

Mono Verde 1999–2002
Oil, ink, polyester resin, glitter, map pins
and elephant dung on linen 182.8 x 121.9

Mono Naranja 1999–2002
Oil, pencil, polyester resin, glitter, map pins
and elephant dung on linen 182.8 x 121.9

Mono Negro 1999–2002
Oil, pencil, polyester resin, glitter, map pins
and elephant dung on linen 182.8 x 121.9

Mono Azul 1999–2002
Oil, acrylic, ink, polyester resin,
glitter, map pins and elephant dung
on linen 182.8 x 121.9

Mono Gris 1999–2002
Oil, acrylic, ink, polyester resin,
glitter, map pins and elephant dung
on linen 182.8 x 121.9

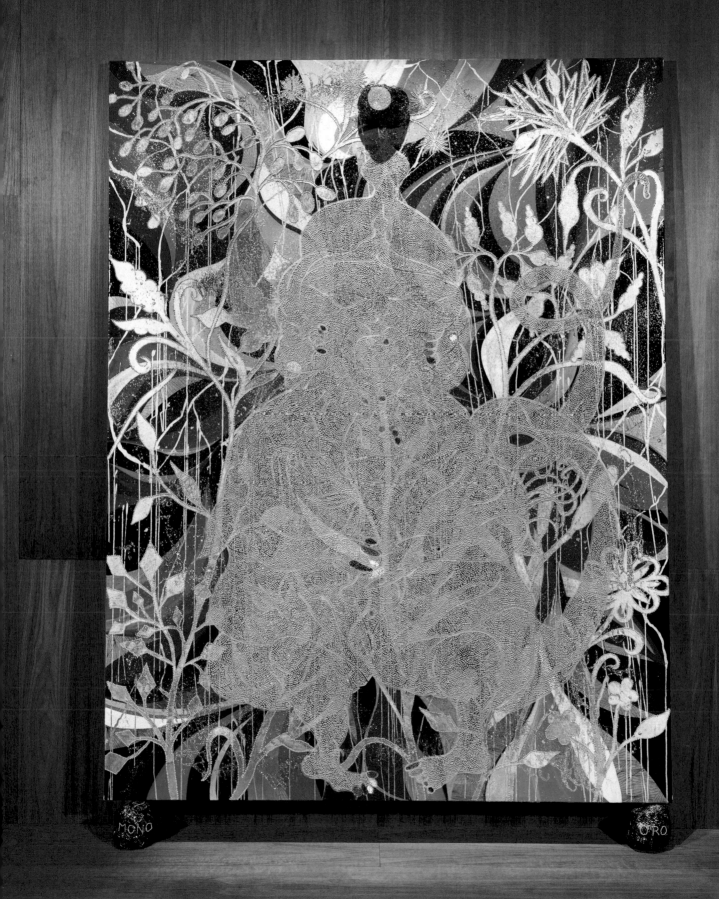

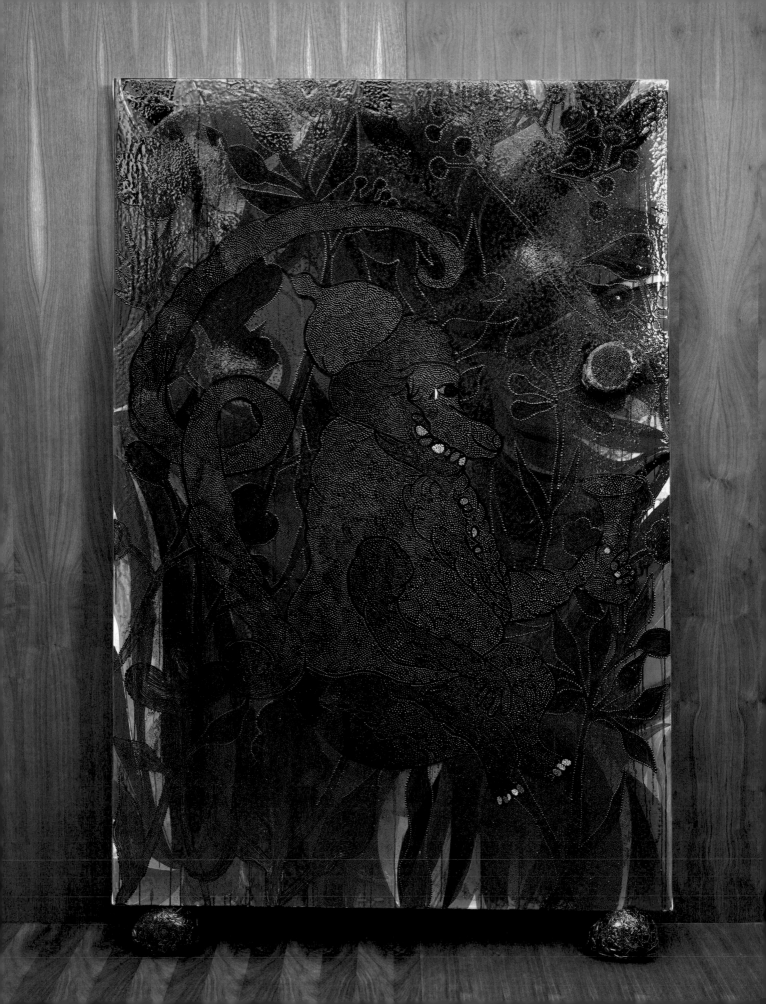

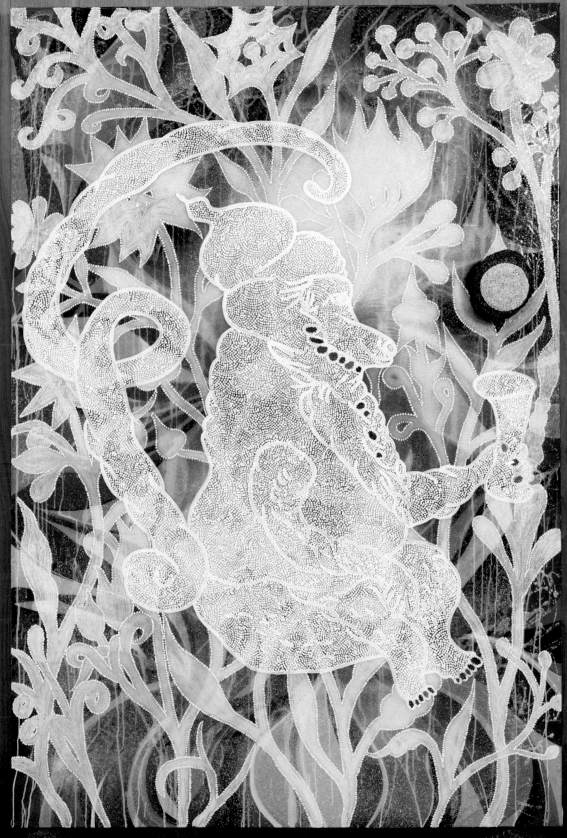

mono blanco

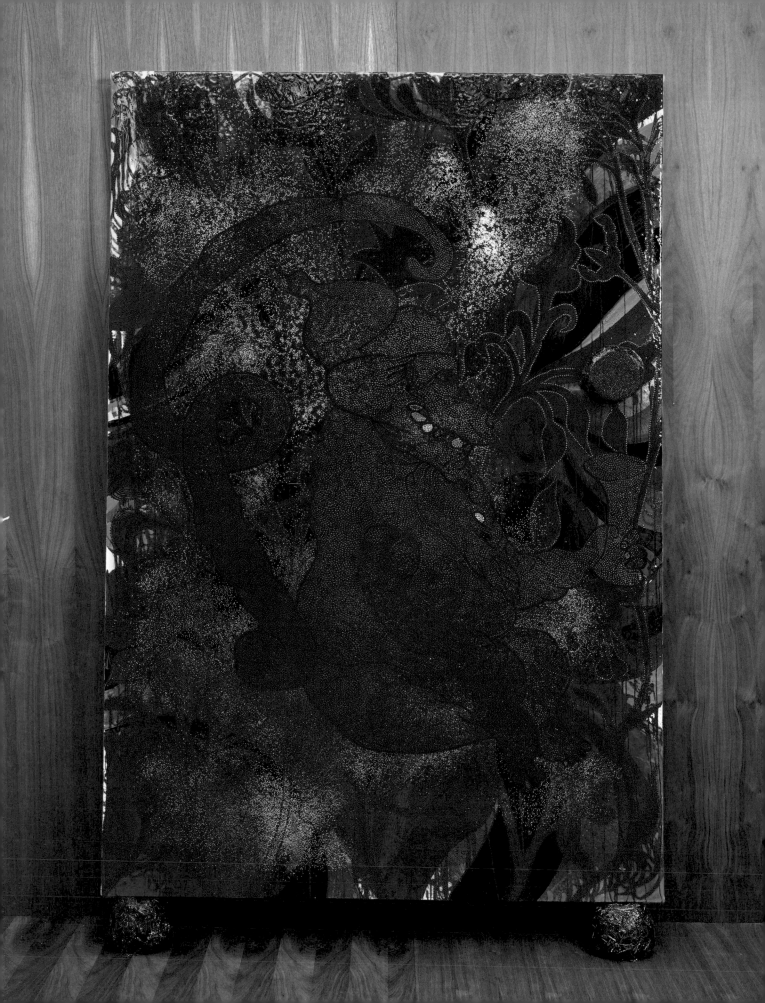

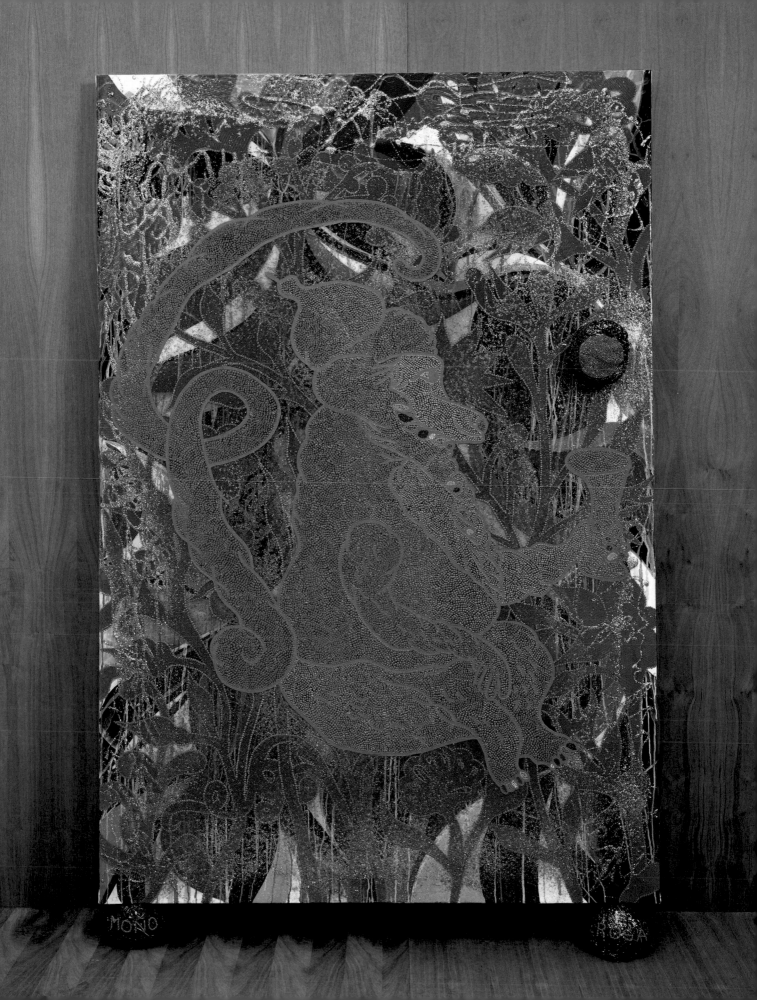

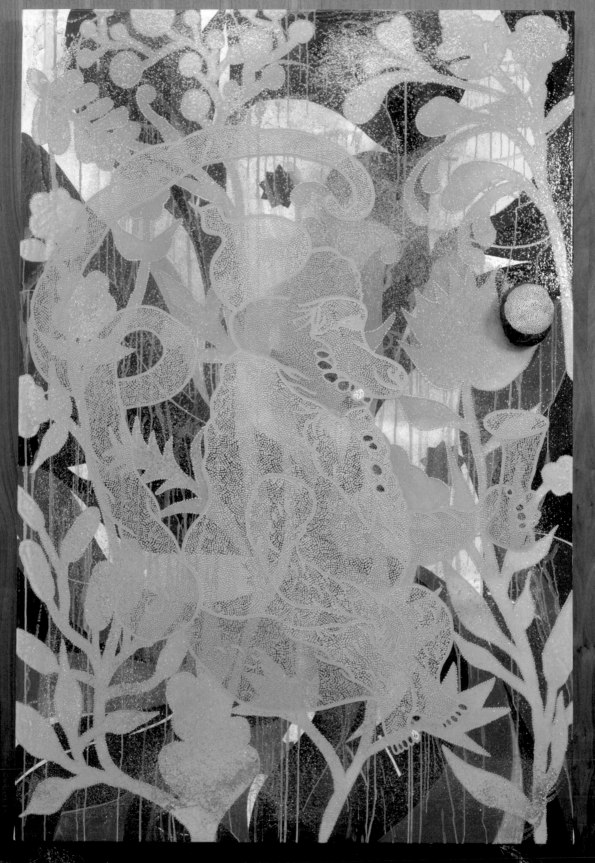

MONO

TURQUESA

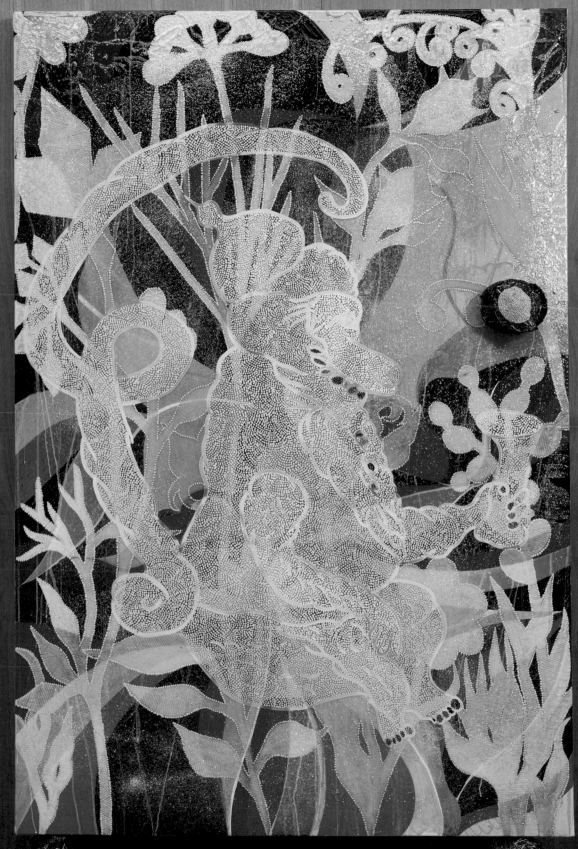

MONO

AMARILLO

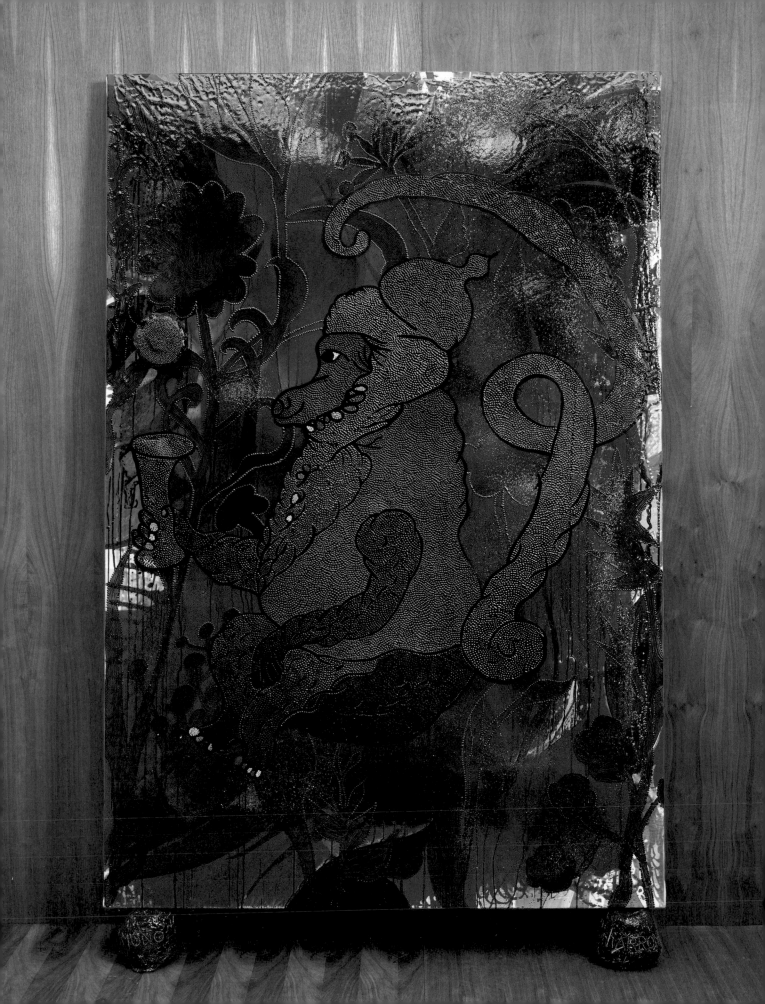

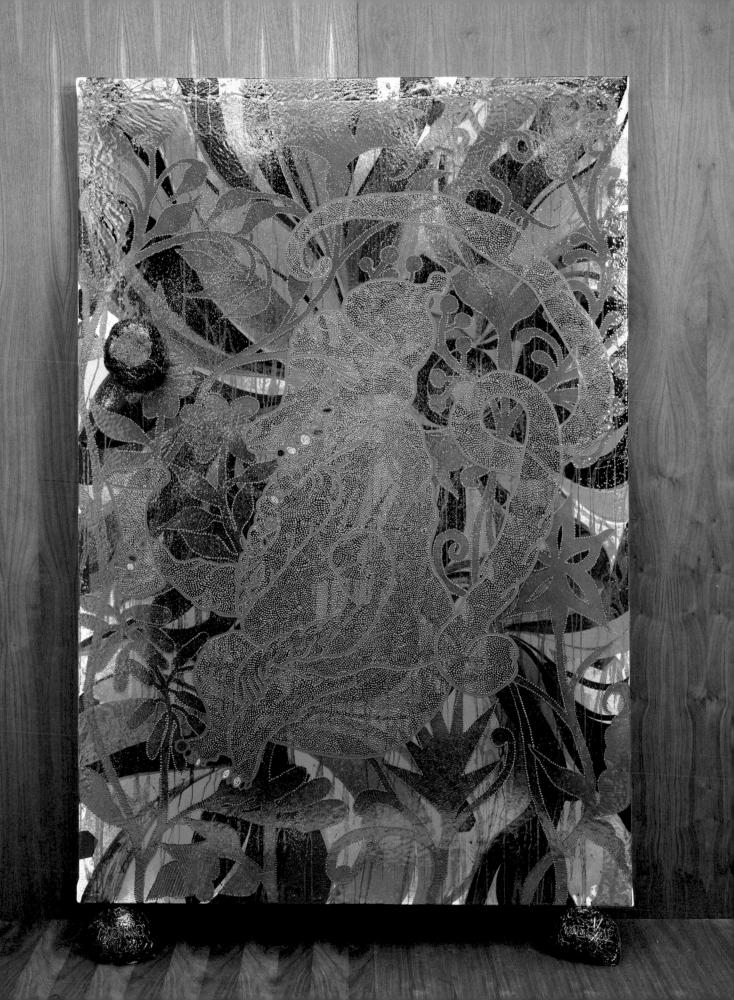

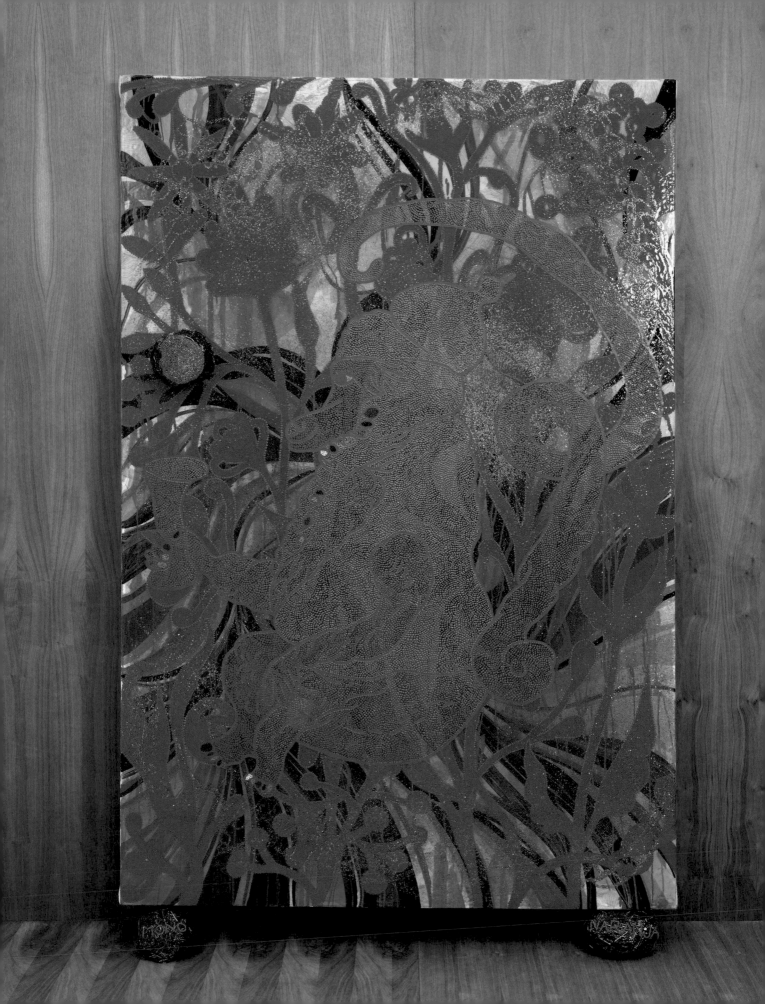

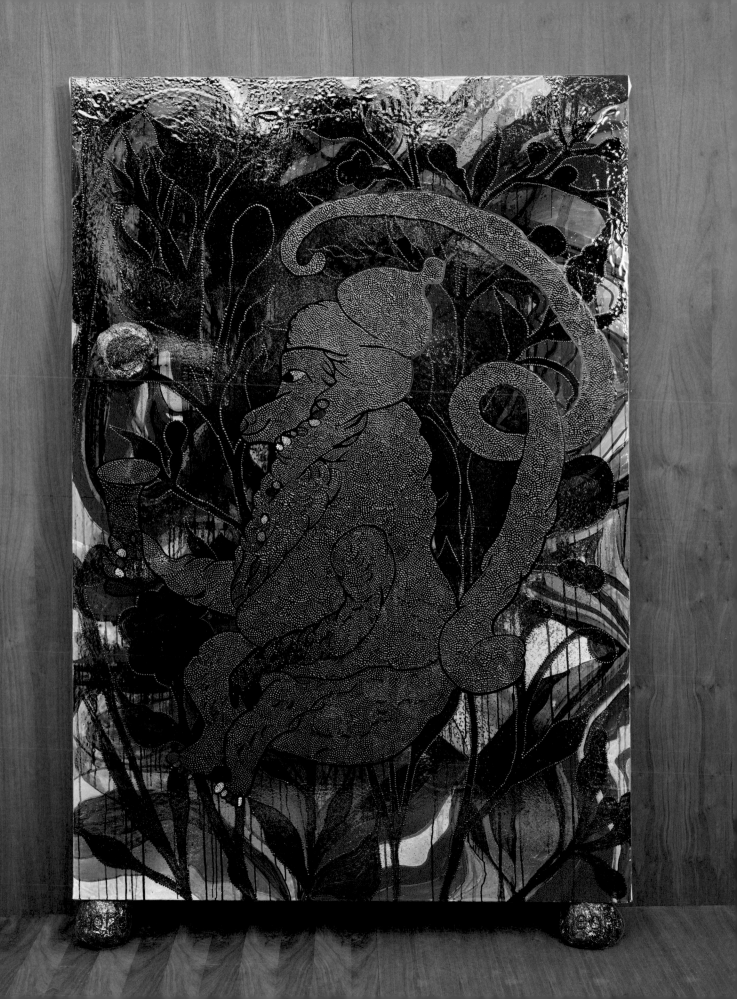

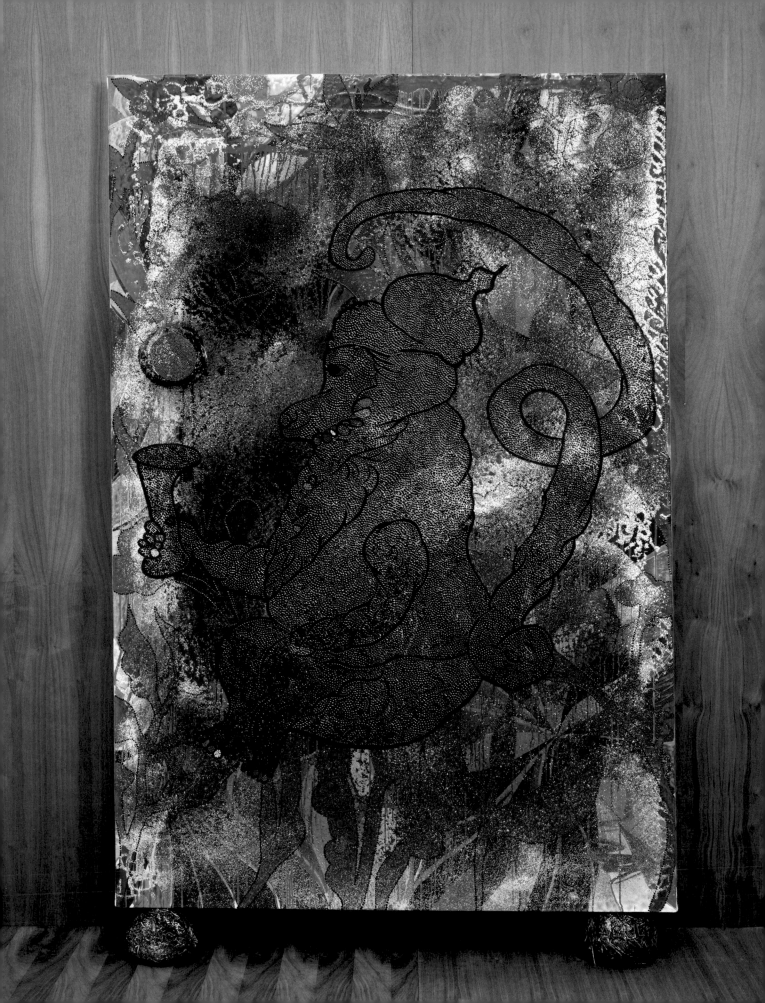

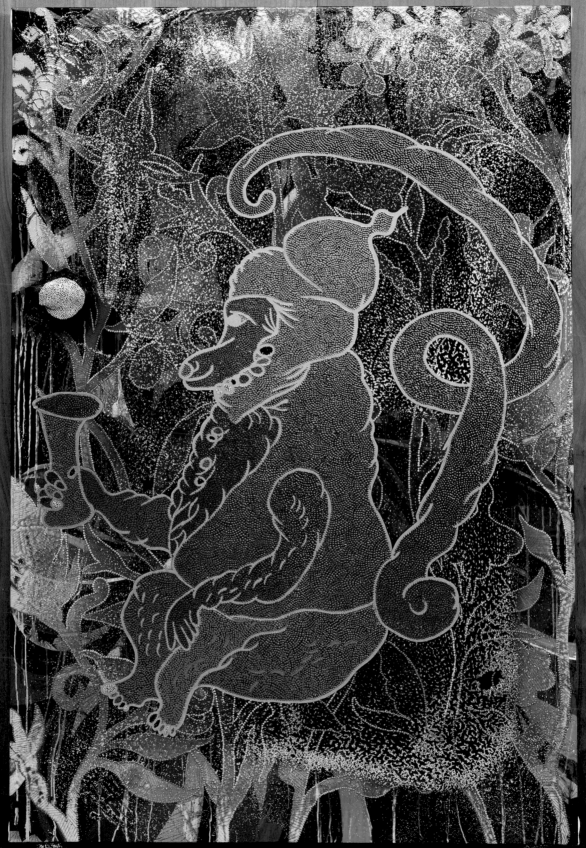

Ekow Eshun interviews Chris Ofili
Edited by Helen Little

EE: Given that we're in your studio in Trinidad, the first thing I'm curious about is what brought you here and what took you away from London?

CO: I felt in some way things had closed down. London was an exciting place to work at one point, because socially it was very progressive – a catalyst. There were very interesting artists making all types of work, but it got to a point where the social aspect became claustrophobic. The fact it was all happening in London became counter-productive, and highlighted the fact that there's a big world out there, and places where there isn't so much vanity about the cultural scene. It also got to a point where I felt the work was really known in a public sense, that the division between public and private was like a thin membrane. And I didn't feel that gave me a greater sense of freedom. The public is not within my control, but the work is, and I wanted to make changes within the work. That couldn't happen in an arena that was familiar to me.

EE: There's a tradition of painters that go away to islands, for example Gauguin. But you work in a different mode in that you're not working from outside as an observer: you're a participant, you're a subject, you're part of this place, and that's an interesting shift. And if one wants to look at it sociologically, you're on a non-white island, you're black and you have a place here that's very different to a white European artist coming away somewhere ...

CO: I have a camouflage. Although I'm not from here, my skin can camouflage that fact, and allow me to be in places that perhaps would be more difficult if I didn't have this camouflage. The camouflage is disguising my gaze, and my excitement and enlightenment in seeing what I see here. The way I look may make it seem this is normal for me, but this is very far from normal, I didn't grow up in a rural environment at all. If I'm by a waterfall, things are running through my head at a million miles an hour, although it may look like I'm lounging.

EE: It seems to me that Trinidad arrives in the work in a number of different ways. Nature has become your secondary palette. Thematically there's also something at play here, and we can see that in the way that the subject matter has shifted. What do you take from around you, from living here?

CO: I take a lot of what this place gives for free, which is a very particular mystery which I value and think might have a place in painting now. Essentially there's a joy I feed off, an excitement about being here and seeing things that have a sublime beauty about them, but an incredible rawness. It's very beautiful and visually very dynamic here. There's a lot to see and it's never boring. As an artist it's an amazing place to have around you, but it can be overwhelming. The three-dimensionality of the place is full-on. You have to let what you see here soak in over a period of time, before you can really work with the full range of this place.

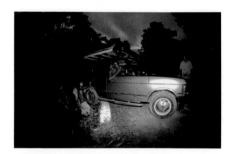

FIG. 28
Exhibition invitation for **The Blue Rider**,
Contemporary Fine Arts, Berlin, 2005

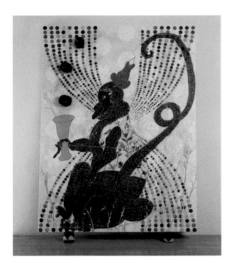

FIG. 29
Monkey Magic – Sex, Money and Drugs 1999
Acrylic, oil, polyester resin, pencil, glitter,
map pins and elephant dung on linen
243.8 x 182.8

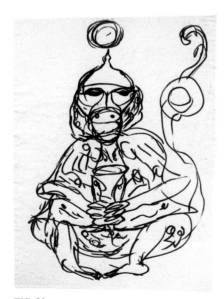

FIG. 30
Drawing for **Mono Oro** 2002
Ink on paper 28.3 x 20.5

EE: I saw *The Healer* 2008 (p.137) for the first time recently. Ostensibly this is a figurative work, because it has a central figure spewing out all this yellow substance. But when we look to the sides of the painting, it starts to move into abstraction. Is this a desire to make it more difficult, more problematic as a painting?

CO: *The Healer* is a fairly simple painting in the way it's put together. The composition is clearly mapped out. But in order for the subject to have any real gravity, I have to create a belief in it. And that's through being around it, working through it, having areas of joy, areas of ambiguity, openness. Those areas might be quite subtle, but for me I know there are ways of painting in there that I would never have allowed to come out of the studio before. *The Healer* had to have mystery about him and the canvas had to feel as though it resonated all of what the healer was about. It's made in oil paint, which is essentially dirt. He's consuming and spewing at the same time – consuming light, effectively, but in the form of this yellow Poui flower, which blossoms in Trinidad and which is in blossom now.

EE: And that's the same shade of yellow?

CO: Yes. What he's doing comes out of my observation of the Poui tree that blooms yellow, and then overnight all the flowers can be found on the ground. I was painting here on Lady Chancellor Hill during a full moon. I had the idea to paint this figure hovering over the landscape, in a Poui tree. So it took me to thinking about this figure as being a kind of guru character. A healer who only comes out at night and has to feast on the flowers to continue. A lot of what Trinidad is about is the feeling of the place, the atmosphere of the place, particularly at night, and the mystery of the forest. And I was trying to get that into the painting.

EE: I think mystery has always been an important aspect of what you seek to explore in your work. For example, *The Upper Room* 1999–2002 (pp.80–95) is completely redolent with mystery. It's a very powerful, intense work that I think would be impossible to make if you didn't surrender yourself completely to the story of the Last Supper, to the possibilities, mystery and drama of that moment.

CO: The story of the Upper Room is written down, but I've imagined it countless times, what it must have been like in that room. It is a very dynamic event in history. It's been painted a lot, and I started thinking about the elements of the story, that Jesus knew that Judas was playing a part in bringing things to an end. I didn't begin thinking, 'Okay, I'm gonna make a version of the Upper Room.' I just started working on a six-by-four painting and was interested in this motif of a monkey carrying a chalice, which I'd worked on in a previous painting, *Monkey Magic – Sex, Money and Drugs* 1999. I took that idea into another canvas. I had one then I had three. And then eventually I thought I could run with it. I had six, all facing one direction, and I knew there was potential to go on to this 'Upper Room'. I really cannot remember at what point the monkeys became representations for the elements of the Last Supper. But they did.

EE: For me, the most powerful effect of *The Upper Room* is its absolute sincerity. We can contrast that with some of the earlier work, such as *Painting with Shit on it* 1993 and *Two Doo Voodoo* 1997 where you use titles that are provocative and playful (pp.24, 43). With *The Upper Room*, there's less of that. There's something else.

CO: It was important for the space to feel akin to a space of worship. I wondered if that was possible, and whether paintings could enhance that feeling. I had the idea for the space once I was part of the way through the process of making the paintings. The two needed to work hand-in-hand. I made some sketches for a room, but I didn't feel that I could design a space that would work well with the paintings, and allow for a viewer to have a total experience of looking at the paintings and revelling in that feeling, which is why I asked David [Adjaye] to help me.

EE: Why did you want to communicate that feeling?

CO: I value it. I place less value on spaces for art that have a lot of people just passing through, which you get in big exhibitions. I thought it would be a valuable experience to suddenly come across a place that was completely standing still, but that had a lot going on within it. The paintings operate in a slow fashion. The colour and activity within each one of the paintings has a power. And then the unity of all the paintings together has another level of power. I'd never had thirteen big paintings in the studio, and never presented that many paintings all at once.

EE: Do you think of yourself as a painter that works with narrative?

CO: Of a sort, yeah. I don't really like that word, I don't really like the word 'abstract' either, although in my head, when I'm working, I work with those words. And 'narrative' sometimes spells 'literal' and 'didactic', which worries me. Sometimes though, I'm just blindingly obvious, an example being *Afrodizzia* 1996 (p.31). Like, bang, there it is. Afro head – celebration of Afrocentricity.

EE: Titles seem to play an interesting part in your work and in some cases – e.g. *The Healer, Lovers' Rock* 2007, *Death & the Roses* 2009 (p.145) and *Strangers from Paradise* 2007–8 (p.125) – they very clearly bear a narrative load. Do these paintings speak to a desire, within that title, to tell a story?

CO: I'm communicating something to do with the way I look at the world. It's exciting for me that things can have an apparent narrative with many potential narratives within it. I have my working title, my reading, but then there are many options for how to interpret something.

FIG. 31
Death & the Roses (in progress) 2009
Photograph by the artist

FIG. 32
Lopinot, Trinidad 2006
Photograph by the artist

FIG. 33
Piero della Francesca
The Flagellation of Christ
c.1455–60
Oil on wood 59 x 81.5

EE: The great theme that you've allowed to emerge through the work over the years is religion. *Iscariot Blues* 2006 (p.123), for example, is a very powerful painting with its mix of the everyday and the extraordinary.

CO: *Iscariot Blues* was made here and came out of my observations and feelings of Trinidad. There are people playing instruments enjoying an evening in a relative darkness. I can hear the sound of the wood creaking as the hanging figure swings. And I can't necessarily get that in the painting, that sound, but it was there when I was trying to paint the painting.

EE: How did the figure of Judas enter the painting? How does he physically enter the frame?

CO: Judas wasn't there at the beginning. He was there because I had a vacant, undecided vertical on the right-hand side of the painting. After I had the idea to put the hanging figure there, the narrative began to construct itself. I was brought up to think that Judas was the bad guy, that Judas betrayed Jesus with a kiss and that he was responsible for the persecution of the Son of God. In further readings, there's an understanding that Judas knew that in order for man to be saved, Jesus would have to die. And the only way for that to happen would be if he was betrayed by those closest to him. So it was interesting that he could be transformed from this 'baddie' to a 'goodie' all of a sudden. There's an energy around this that I felt was worth finding a picture to depict. The figure of Judas stayed because it had enough of an ambiguity about why he was there and it allowed the painting to separate into two halves, two sections. I was interested in a kind of violence, a psychological, passive violence, leaving a dead figure hanging. And the kind of stillness, and the nonchalance of the musicians.

EE: How much of your work is a rediscovery or resuscitation of childhood experiences? How much is a lived exploration of those themes, ideas or emotions?

CO: I was an altar boy and heard the Bible being read out repeatedly. The stories have stayed with me, although they're completely remixed in my head. And often when I do further reading, I'm quite surprised by the difference between the real story and my memory of the story. I'm interested in that difference and how it's affected the way I think about making images. But I'm comfortable with that. I don't particularly want to be spot-on. I'm fortunate in that religion has played an important part in the history of painting. When I go on a trip to look at frescoes, some of my themes are up there on the wall. *Death & the Roses* came out of ideas about flagellation and guilt, and from looking at Piero della Francesca's *The Flagellation of Christ*. In my painting, the guy on the right with his white shirt comes from contemporary images of Trinidad stick-fighting. He's also dressed a little bit like how farmers and hunters dress in the forest. A lot of these ideas are based in reality, but are imagined, fictional occurrences. That's something I work with a little bit more now.

EE: You've made works that reference Jesus in the Garden of Gethsemane, the Annunciation, and other elements of the Bible you grew up with. What is it you find in the Bible now?

CO: Stories within the Bible still have a relevance to my life and contemporary life in general. I'm still interested in ideas of morality. Last night I was thinking about how Christianity has structured the way we live our lives now. We still have a clear idea of what's right and wrong, and that has some parallels with what's considered right and wrong in the Bible. The stories are so well put together that they evoke very powerful images.

EE: You seem comfortable with the mystery involved in what it is you're expressing. Are you having a public conversation right now in ways you were before? Are the works more private, more public or more revealing?

CO: I think there are more unknowns in the work for me now, in narrative. Previously, I would have needed to link my work to historical events, and be able to explain exactly what's going on. But now I'm more comfortable with not being able to pin down what's going on, and why. I'm at the beginning of something new. There's a newfound confidence in the way I'm working, that I wouldn't have been able to tolerate ten years ago.

EE: Talk me through some of the process of creating the works.

CO: I tend to work from different sources, either from photos that I've taken, observations of historical paintings, or ideas generated through literature, music and discussion. I'm no longer trying for the big painting to be the definitive way of realising the idea. A large painting is not the only option for how an idea or composition can be realised, and a lot of ideas for an image might manifest in different forms and variations, in a drawing, either directly on the canvas, or in a sketchbook, or on a sheet of paper. And I try to work through the elements – different figures or different colour studies, either keeping the elements separate, or working through them as a whole composition, moving and changing things around. It's to do with things falling into place at the right time, in a painting or a drawing, and sometimes with a drawing you can be more relaxed.

EE: There is more than one version of *The Raising of Lazarus* 2007 (p.131). What's the distinction between each of those as works?

CO: There are two large paintings, *The Raising of Lazarus* and *Lazarus (Dream)* (opposite right). In *The Raising of Lazarus*, it took a while to get the image to fall into place and get the figures to sit right. As I was trying to get the horizontal figure to work, I was drawing it and redrawing it, and then the redrawing became some kind of signifier for the figure rising up, so you see

FIG. 34 (left)
Douen's Dance 2007
Oil on linen 281 x 194.9

FIG. 35 (right)
Lazarus (Dream) 2007
Oil on linen 278.5 x 200

him in three different states. The second painting, *Lazarus (Dream)* was painted more quickly, and I was a lot clearer about where I wanted the figure, the palm tree and the bubble of the two people dancing to fall. So the energy of the first painting took me to the second one which became another version to a degree, but also separate in its own right.

EE: What I was struck by when I first saw the *Christmas Eve* series of paintings (see fig.34, above left and *Christmas Eve [Palms]*, p.133) was that there's a lot of working out of the two figures. They become more about a geometry of colour and abstraction, as the two figures seem to disappear into the canvas and become more refracted. You seem to be really interested in is how far you can take them, whilst retaining a clarity of detail.

CO: Looking at Malick Sidibé's photograph *Nuit de Noel* 1963, which inspired
 these works, I read it as a photograph of tension between two elements,
 two figures. A certain kind of electricity or magnetism exists between the
 two figures, because the heads are not quite touching. In some of my
 drawings, the heads touch. I became interested in them being as one.

EE: What is fascinating to you about this photograph? It's a found image, but
 one could say it's also a profound image, inasmuch as it sums up a lot of
 Malick Sidibé's *oeuvre* of working with ordinary African people at moments
 of joyousness or intimacy and so on. So it's not that you've just taken any
 photo, it's a very particular image.

CO: I saw it and was struck by it. And then I found out it's one of his most
 famous photo. It's a beautiful and compelling black and white photograph
 of two figures, a male and female who I'm told are in fact brother and sister
 – dancing together. She's wearing no shoes, he's wearing shoes; he has
 formal clothes, she has a light-coloured dress. I like the fact that they're
 both looking down at the motion of their legs. There's a sense of them being
 enclosed in one world, oblivious to what's going on around them. When I'm
 working through it in painting or drawing, I hear the shuffling of her feet on
 the concrete. That sound's a very particular sound, it's impossible to paint,
 but it's a beautiful sound. I'm not sure what music they're listening to, but
 I think somewhere in the background there's a seated figure, who may be
 controlling the record-player. It has a narrative that's of the moment, but
 also a narrative of anyone who may have danced and enjoyed music. It has
 a nostalgic beauty. I think the image is worth using as a springboard for
 paintings of figures dancing in a space that allows you to feel that they are
 lost in themselves.

EE: One of the things that comes across from listening to you talk about Trinidad
 is both your fascination and fidelity to this island. You're not trying to illustrate
 this island, but it has a strong presence in your imagination, as you're about
 to or as you're in the process of working. How has this happened?

CO: I came here with an open book. And at the same time I had the desire for
 my work to be influenced by the place. I didn't want to make paintings that
 were to do with another place. My last body of work, the red, black and
 green paintings, were influenced by a visit here in 2000, so I thought it
 would be a rich vein to work in. I never really knew, and I still don't know,
 where that might take the work. But I think there's a sincerity about the
 place that encourages me to surrender to it, allowing the work to retain
 some of that sincerity of form, of light and shade, narrative, composition,
 dynamism – of many feelings of emotion. It's to do with dropping my barriers
 and somehow becoming more of a conduit for different types of energies.

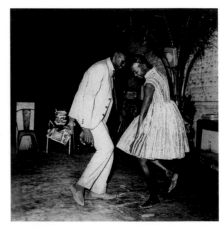

FIG. 36
Malick Sidibé
Nuit de Noel 1963
Photograph

EE: What's so special about the night here?

CO: I've found that the night and twilight here enhances the imagination.
In the city our relationship to the night is very particular because it's always
illuminated, but here it's unlit, so you're relying on the light of the moon
and sensitivity of the eyes. It's a different level of consciousness that is less
familiar to me, and stimulating through a degree of fear and mystery. It wakes
the senses. You won't see any birds but you'll see bats flying around and
you'll hear different insects. Vegetation moves differently. The moonlight
reflects off moist surfaces. Most of what you see is what you think you see,
it's not actually what's in front of you. And if the mind is in a particular state
you'll open up the possibilities of what you're seeing, which may be purely
imagined. I think the use of photography almost expires at that point,
and the projection just goes into your mind's eye and into the brain.

EE: By day you do make notes with photographs?

CO: I take thousands of photos here. I've taken more photographs here than
I've taken anywhere else in the world. By allowing the camera to be my
eye and my recording device, when I look back at photos I'll see things in
a figure or a place that I couldn't see with my own eyes. I've certainly done
that after visiting waterfalls, because when you're there, there's so much
going on, so much sound and wind and motion, it's difficult to see how
the waterfall is actually moving as it falls. And later when I go back again,
I can look for those things in more detail and see how they look to me when
I see them with my naked eye. I used photography a lot less in the past,
now I find that I make more drawings from life and also use photography
as a form of sketching.

EE: *Death & the Roses* feels fairly ungrounded in a known world. And yet comes
out of your experiencing, imagining the locations you're in.

CO: Yes. You see somebody in a waterfall in reality and it's just almost
impossible to capture what's going on. With a primary source there's
so much to distil it's almost overwhelming. What I try to do is accept
that you've got certain limitations and work with them. Not that you're
eternally disappointed in what you do, but you know that there's always
room for more. And I think that's the feeling that I've tried to adjust to,
that you can't do it all. But ultimately it's important to be in a place
where you can have a lot to distil.

FIG. 37
Habio Falls, Rincon Valley, Trinidad,
2 September 2009
Photograph by the artist

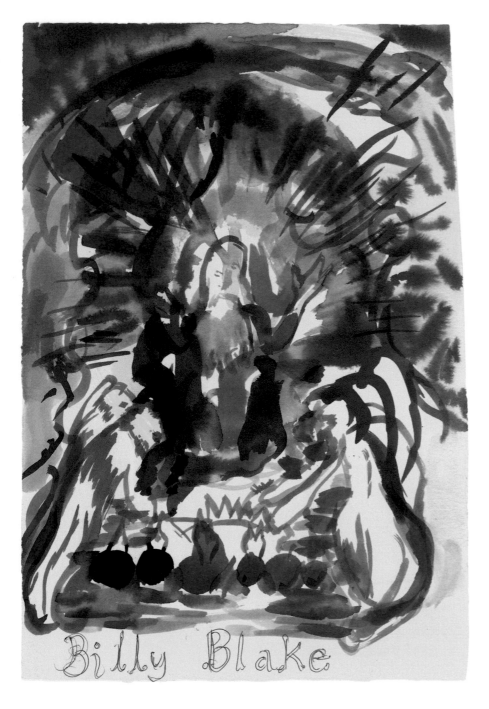

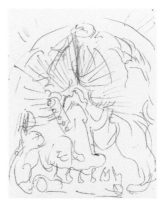

EE: Do you think you tried to do it all, in your earlier paintings? That collage effect?

CO: In the earlier work, there was less filtering going on – it was about doing the maximum. It all took place within the painting. It was a bit like throwing all the cast of characters on the stage – we may only speak or listen to a few at a particular time, but they all stay on stage. More recently I work through a painting by doing less and less. Now there's a slightly different approach, in that the characters that come on are only those that need to be there. There's more interest in the set, as well as the characters.

EE: It is interesting how many sources end up in the work in one way or another. William Blake has been an artist you have to returned to time and again. One might say that Blake's work exists on three levels. There's the temporal, there's the spiritual, but also then the mythic and the visionary. Is that at least one point where you might find a crossover?

CO: I think a lot can be learned from Blake. *The Four and Twenty Elders Casting their Crowns before the Divine Throne* c.1803–5 (see p.13) formed the basis of a painting of mine, *7 Bitches Tossing their Pussies before the Divine Dung* 1995 (p.25). I was drawn to Blake's image first as a watercolour, which I saw at the Tate. At the same time I was interested in how Snoop Dogg could sing quite vulgar lyrics with a sweet, smooth West Coast voice – in the coming together of the rough and the smooth. I was curious about trying to make older ideas contemporary and new, and somehow have a relationship to hip-hop culture at the time. It was important that the title was a tough, playful, funny or silly title that would have its roots and references in something that was really quite different to it. I went to the Tate and made a number of drawings directly from the Blake, and then worked in the studio with collage and paint and other materials to try to make this painting.

EE: In the context of your exhibition at Tate Britain, how does it feel, looking back through this work?

CO: I don't feel I'm looking back; I'm looking around the work. The exhibition in London is an opportunity to see what I can pull from different aspects of the work we're bringing together, to take me forwards again. We can only say looking back in terms of chronology. Ideas are continually recurring and do not only exist in the past. So I wouldn't want to relegate something to being an old idea, the date doesn't matter.

For instance, you hear an amazing Thelonius Monk track, and the last thing that occurs to you is whether or not it was made at the beginning of his life or at the end of his life. First thing that strikes you is that it's just a surprising arrangement of sounds. Of individual sounds to make a whole.

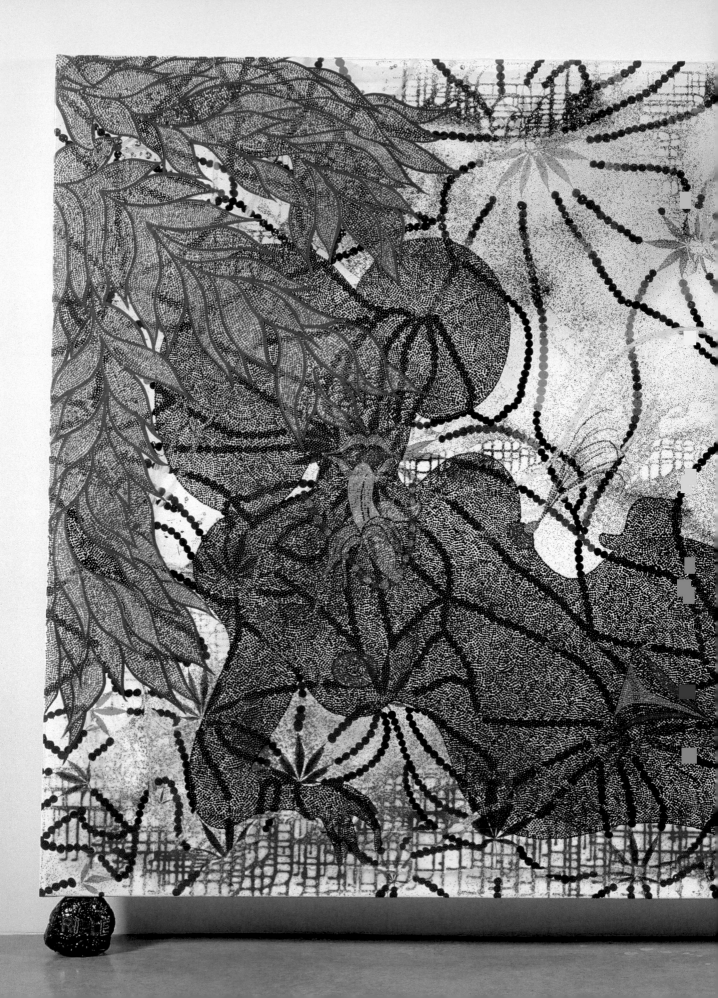

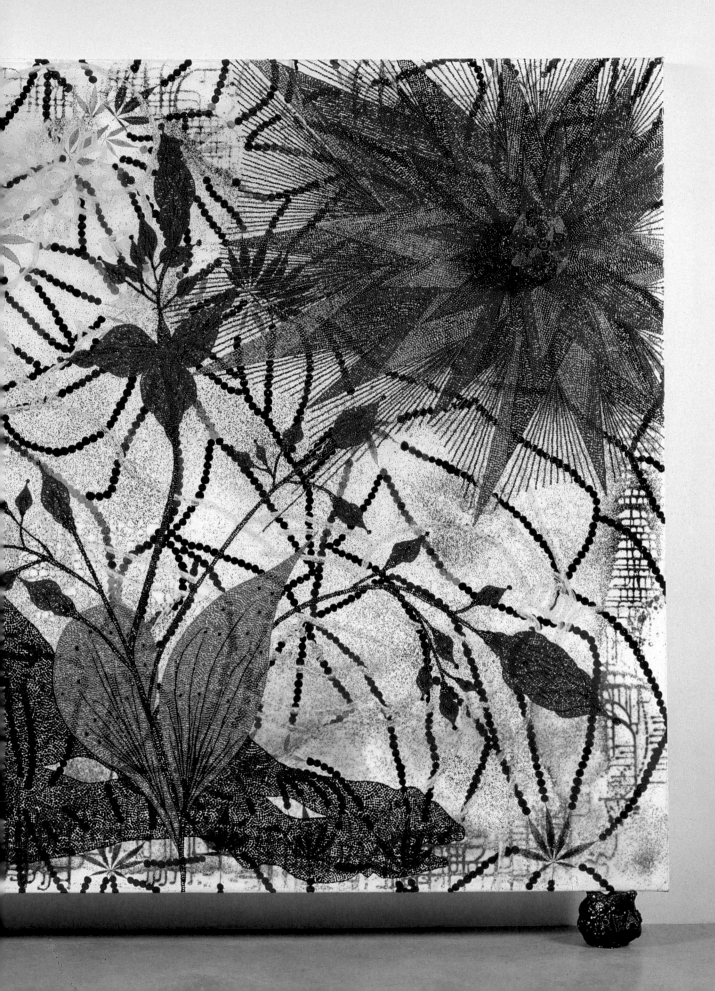

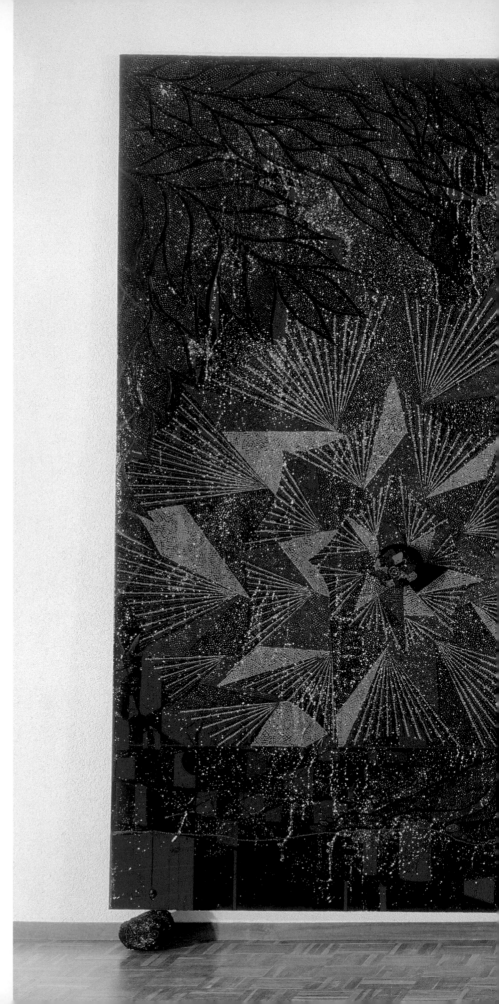

Previous page
Triple Beam Dreamer 2001–2
Acrylic, oil, leaves, glitter, polyester
resin, map pins and elephant dung
on linen 182.8 x 304.8

Afro Sunrise 2002–3
Acrylic, oil, polyester resin, paper collage,
glitter, map pins and elephant dung
on canvas 275 x 366

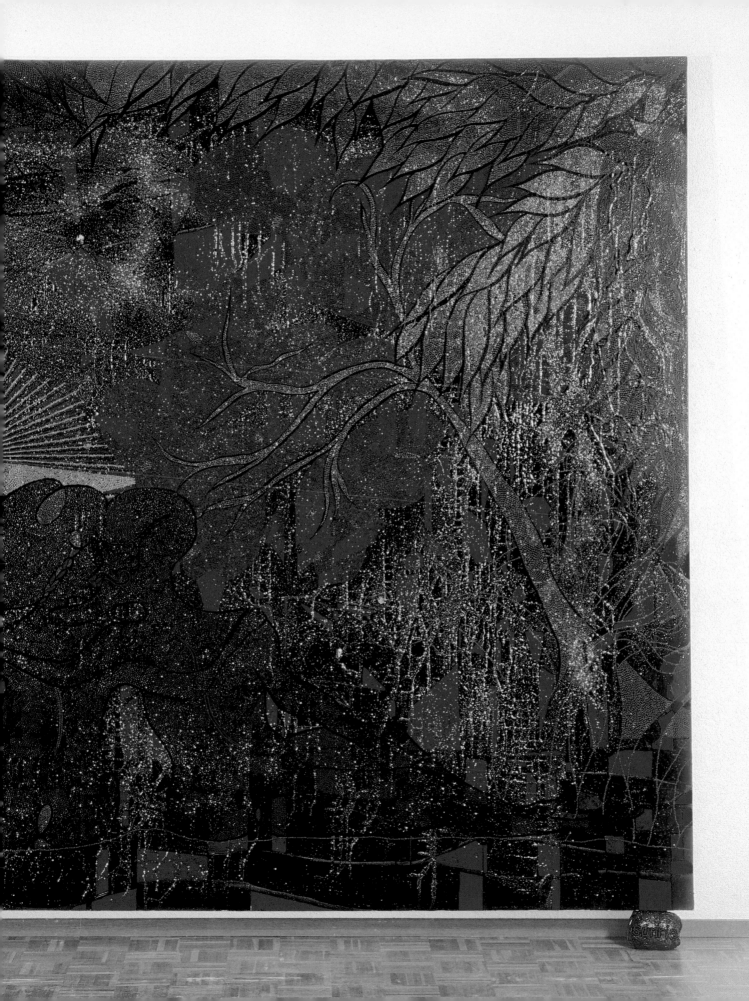

Afro Love and Unity 2002
Oil, acrylic, polyester resin, glitter, map pins
and elephant dung on linen 213.3 x 152.4

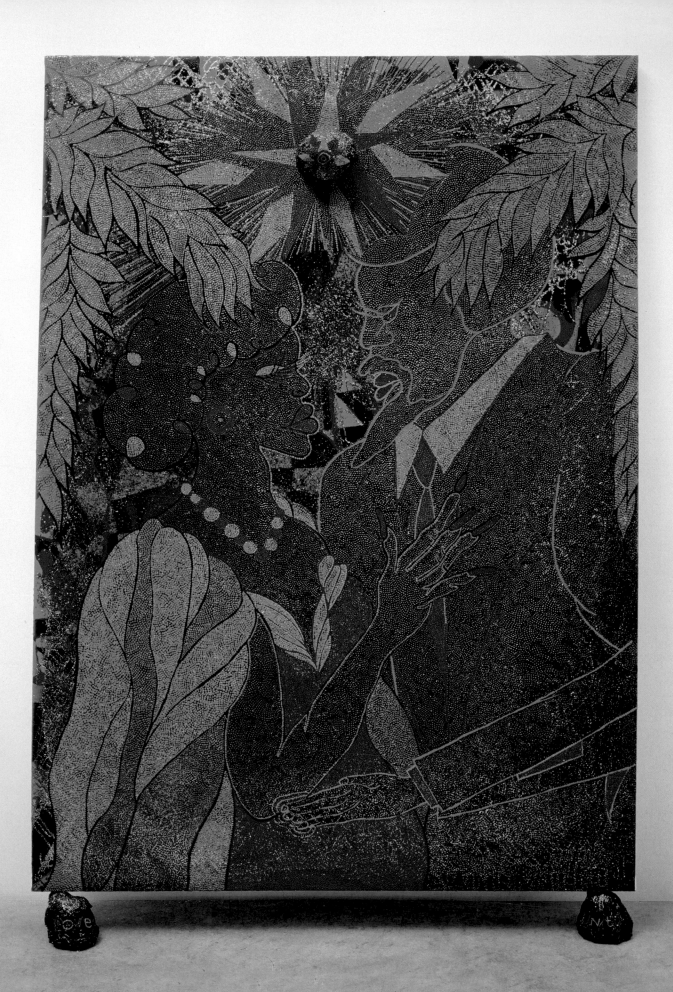

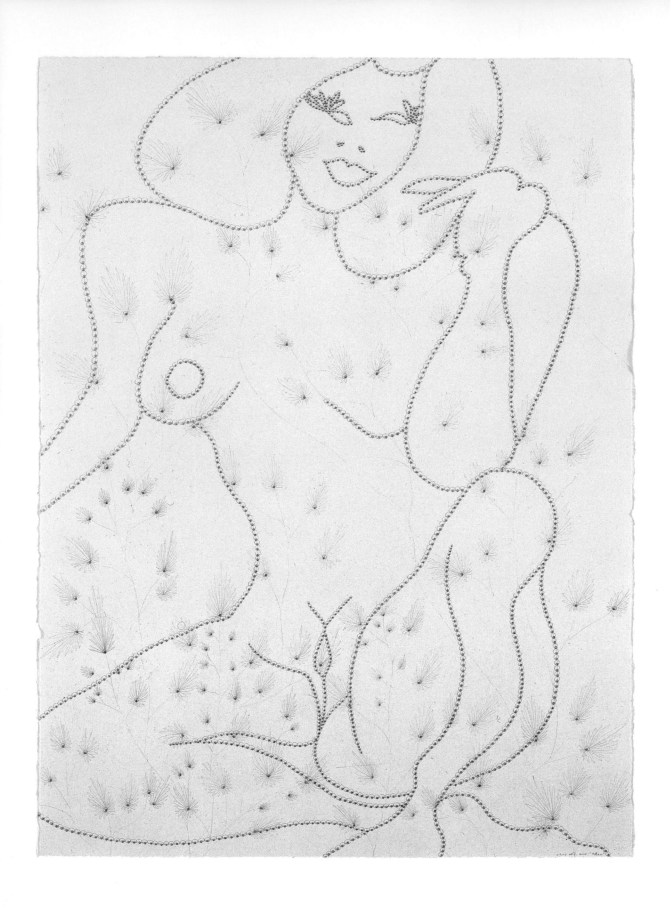

Adam (7 brides for 7 bros) 2004–6
Pencil on paper 76.2 x 57.2

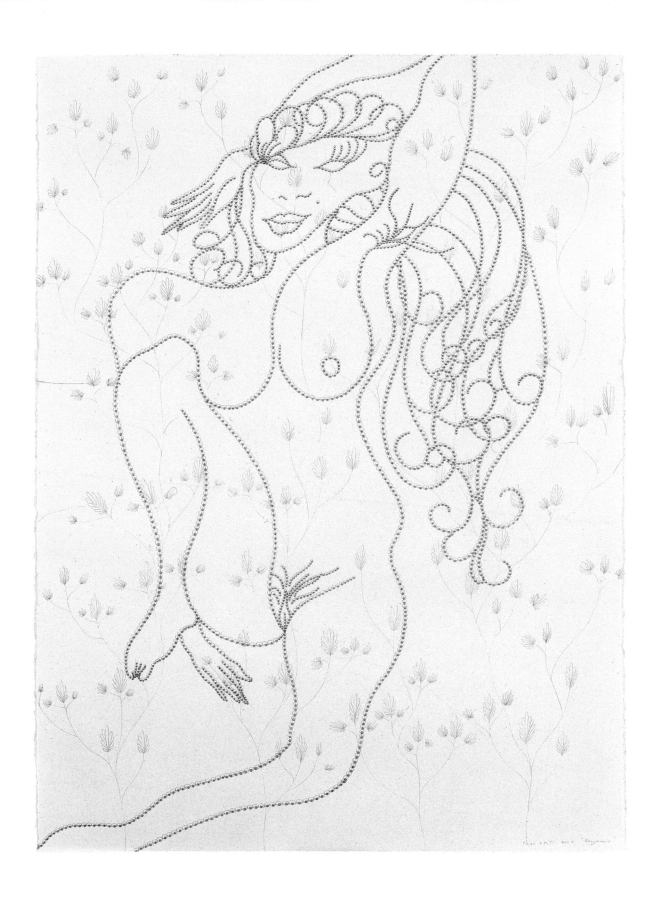

Benjamin (7 brides for 7 bros) 2006
Pencil on paper 76.2 x 57.2

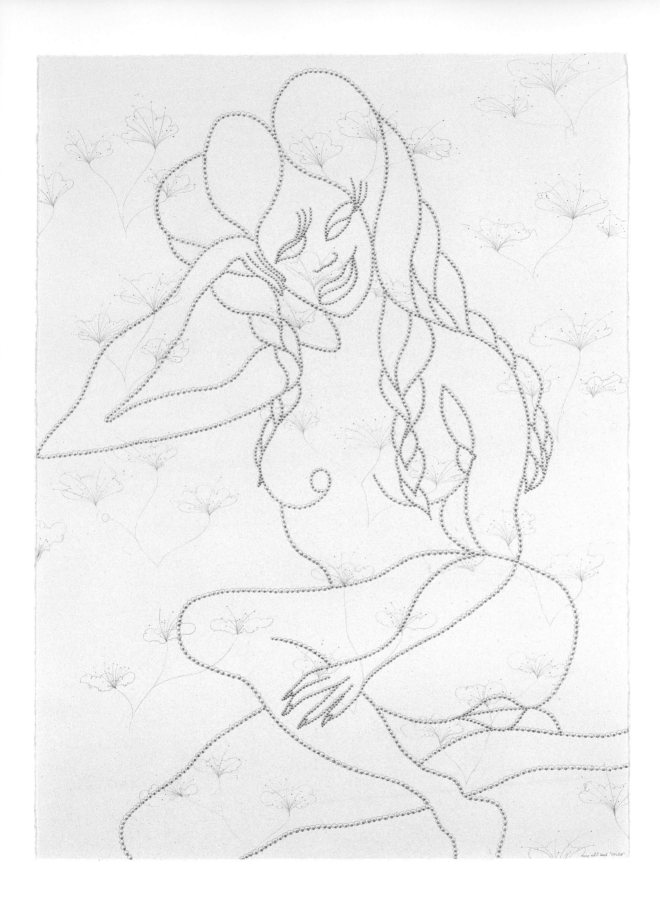

Caleb (7 brides for 7 bros) 2006
Pencil on paper 76.2 x 57.2

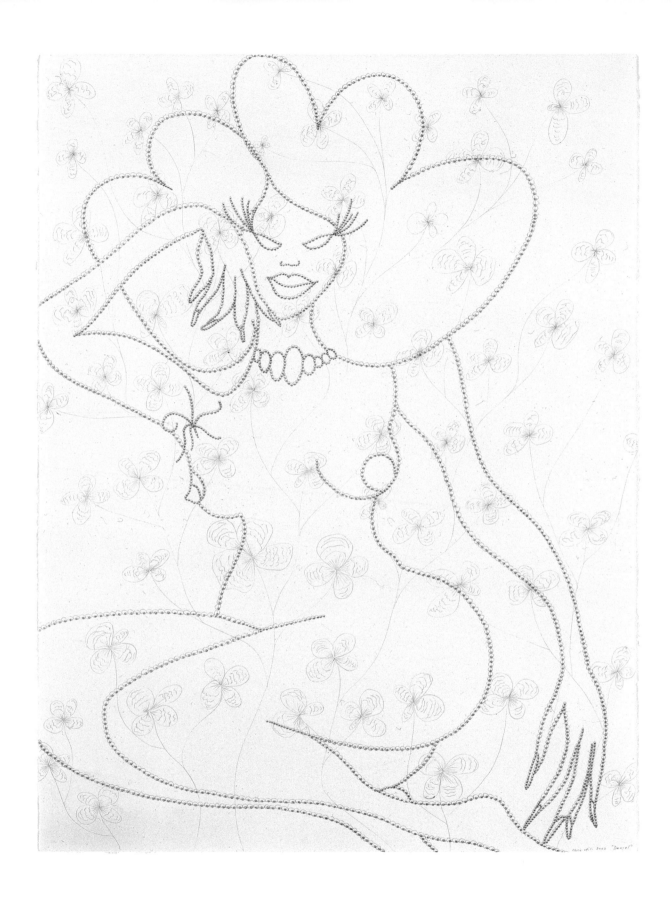

Daniel (7 brides for 7 bros) 2006
Pencil on paper 76.2 x 57.2

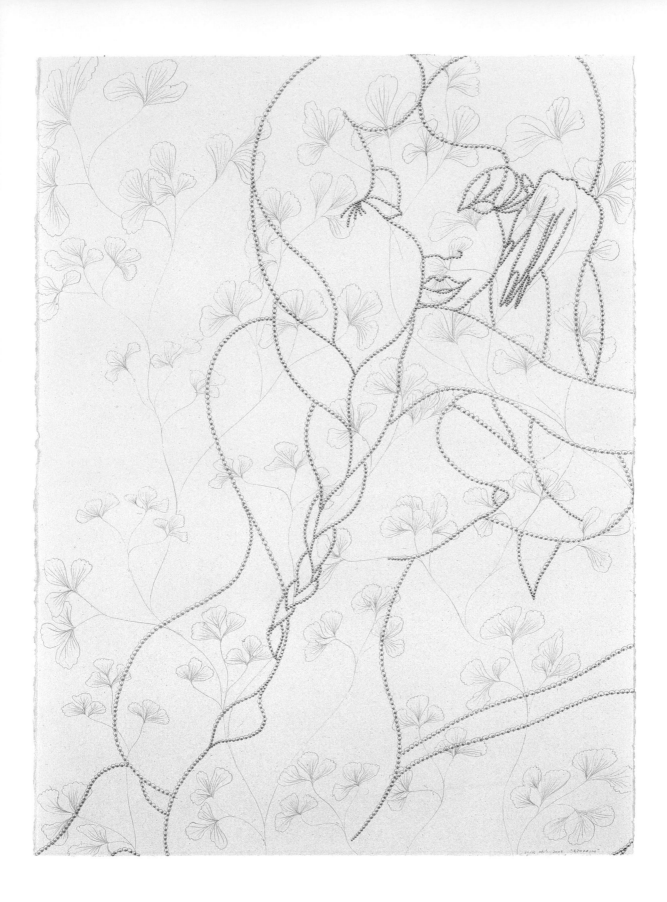

Ephraim (7 brides for 7 bros) 2006
Pencil on paper 76.2 x 57.2

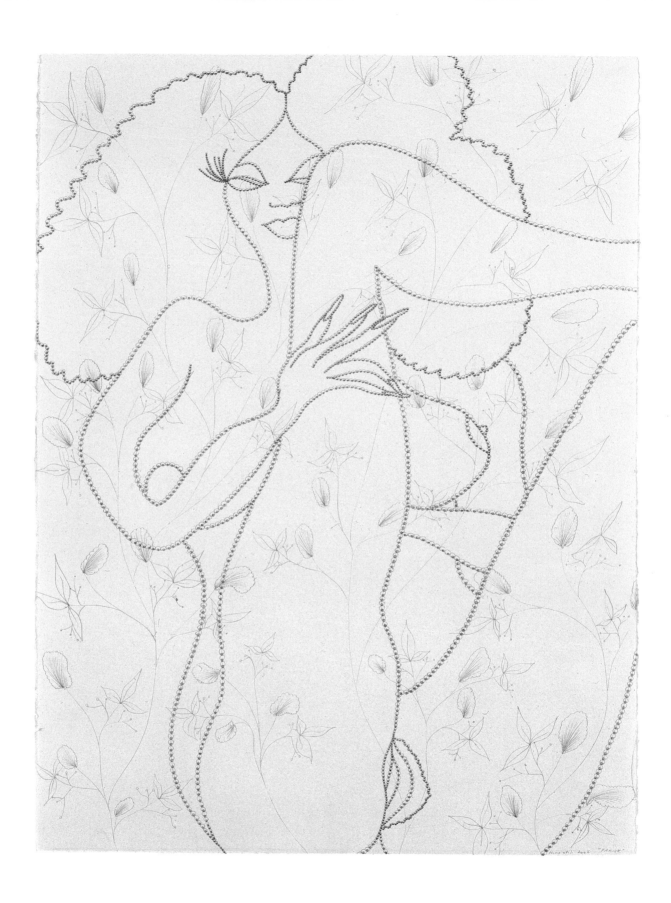

Frank (7 brides for 7 bros) 2006
Pencil on paper 76.2 x 57.2

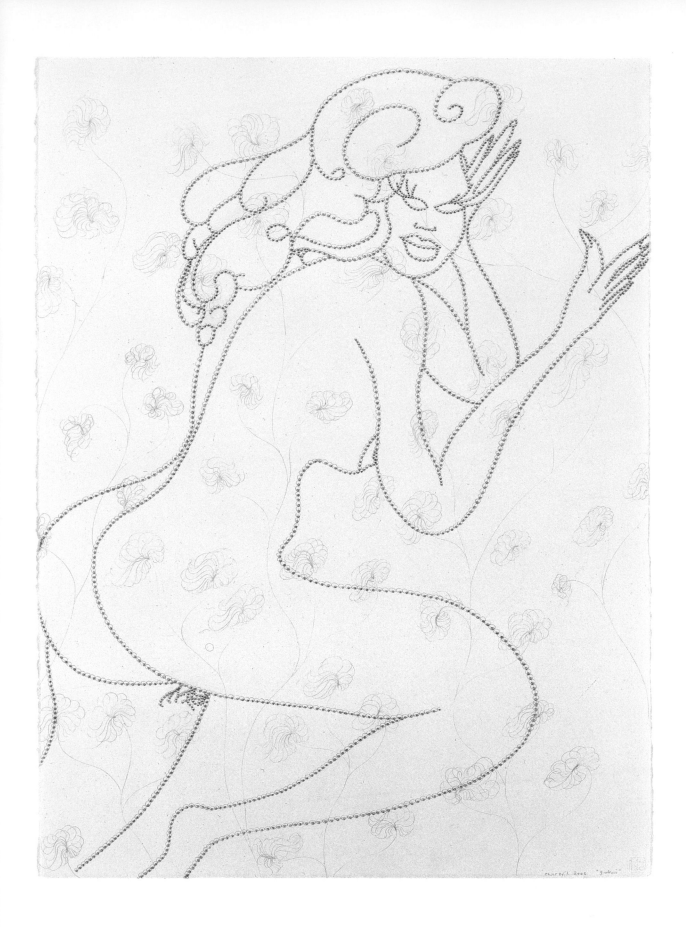

Gideon (7 brides for 7 bros) 2006
Pencil on paper 76.2 x 57.2

Blue Riders 2006
Oil, acrylic and charcoal on linen 278.4 x 200.2

Iscariot Blues 2006
Oil and charcoal on linen 281 x 194.9

Strangers from Paradise 2007–8
Oil and charcoal on linen 280.3 x 195.5

Blue Stag (All Fours) 2008–9
Oil on linen 280.7 x 196.3

Confession (Lady Chancellor) 2007
Oil on linen 281 x 195.3

The Raising of Lazarus 2007
Oil and charcoal on linen 278.7 x 200.4

Christmas Eve (Palms) 2007
Oil, pastel, charcoal, aluminium foil
and paper collage on linen 281 x 195.3

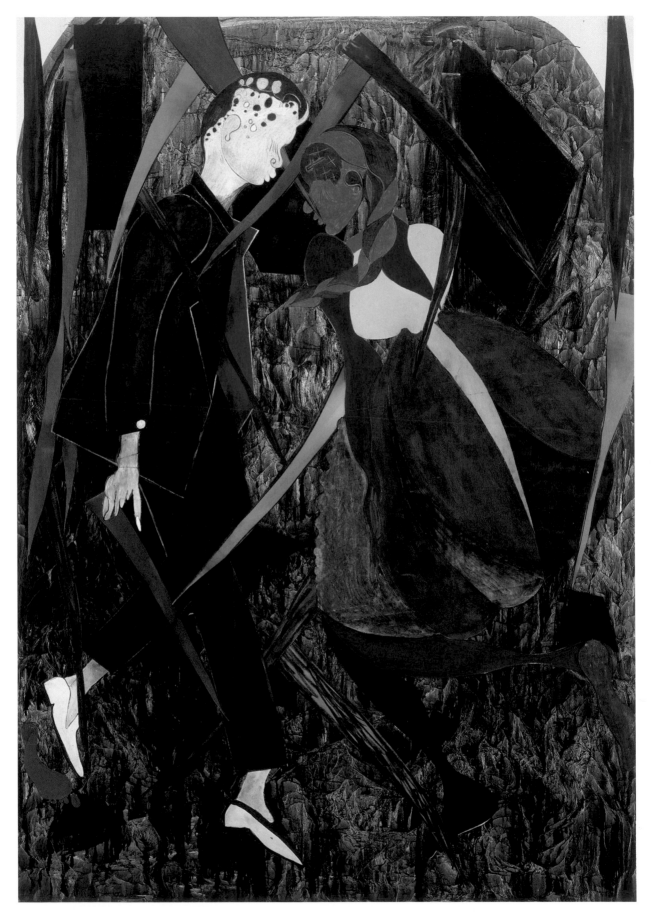

The Healer
Attillah Springer

Take this island like a dose of medicine. To heal your centuries of wandering.
Find yourself here. As if in a dream. Emerging from the mists of afternoon
thunder storms.

The earth smells new, there is already a place for your footprint in the soft ground.
In your ears the sound of freely flowing water.

It is easy to overdose here. It is easy to prescribe yourself too much of this healing.
Be careful not to poison yourself with this island medicine.

*He emerged fully grown and dripping. Old already. He had formed himself
in the depths of the blackest part of the pitch lake's womb.*

Pick this, it is a plant whose name you do not know. Its leaves are pungent
enough to make your mouth wet with desire.

It smells of lost childhood. When you ate mangoes by the bucket and licked
the tiny rivers of juice that ran down your arms.

And then you danced and washed yourself in the rain and disemboweled
a thousand rain flies to see how their insides looked.

Put it in your mouth and wince. It is much more bitter than you expected.

Weep now for your lost childhood. Weep now for children disemboweled like
a thousand rain flies. Step over their broken bodies. The smell of rain and earth
and blood is everywhere.

*The bitumen smell follows him. Silent as falling Poui flowers he walks in the
forest picking leaves and pulling roots.*

Drink this. Taste this island on your tongue, cool and wet. You have not ever known
sweetness like this. Feel it in your throat. Feel it spreading through your body. Feel
this island under your skin. Feel yourself expand and explode with understanding.
Let this island medicine intoxicate you. Let the liquor dance
a spirit dance in your veins.

*He carries a staff and a bag made of the skin of animals. He thanks the spirits
of these animals for their sacrifice.*

Eat this. It is the texture of dawn. The strings wedge themselves in your teeth.
Let them stay there for the rest of the day as joyous reminders of the moment when
your hunger was sated. Nourish yourself on fruits and plants that spring out of
fecund earth with a startling greenness. The landscape was edible once, but these
days the only plants they want to grow are industrial. This place on your tongue
is a thousand lacerations of fruit eaten before it is ripe.

Only the most powerful of priests dare enter the forest in search of his healing medicines.

Take this island at face value. It is so beautiful sometimes you have to shield your eyes from the glare. Imagine that no anger simmers behind those eyes. No resentment ever got between those lovers in their strangling embrace. The people are in love with this here and this now. Obsessed with its youth and beauty. Expect that everything is alright. The sun shines and people smile and shake their beautiful backsides to festival music. It is the happiest sad place you have ever seen.

He is calling you into the bush. You have nothing to fear.

This is the bush bath you have been looking for. Sap your skin with leaves. Waterfalls pound your head into shape. Let the sea beat your longing out of you. Let your confusion pour from your nose. Cough up your inhibitions. Spit them into the waves. Tumble and let the water kiss your shoulders. Sit in the sand and watch the horizon for your returning joy. The sea is wide and loud here. And rocks jut out at strange angles from the sand. The sea roars in your ears and all you want to do is sleep.

His eyes see much more than his mouth says. Walking by himself in the moonlight.

See this place, but not with your eyes. See things that may or may not be there. Let it delude you into thinking that everything is alright. But you sense spirits here. Angry spirits and playful ones. Restless spirits to whom no priest or pundit bid farewell. Silent ones who appear to you in dreams. You do not know their names. They demand recognition. You have forgotten them. Like the names of your ancestors. Strange names of disparate tongues, from far-flung places.

Sometimes, when the moon is full and the Poui is bright you can see him dancing in the places where electric lights have no power.

Call this island's name. Like it is the name of your God and you are a most willing devotee. See God in everything. And when you pray, ask for understanding.

And when you can tell the difference between shadow and spirit, when your eyes get used to the darkness, you will find that this island is your greatest fear and your last chance for salvation.

Can you see him moving there in the shadows? Can you distinguish his skin from the bark of those trees?

The Healer 2008
Oil on linen 310.5 x 200.6

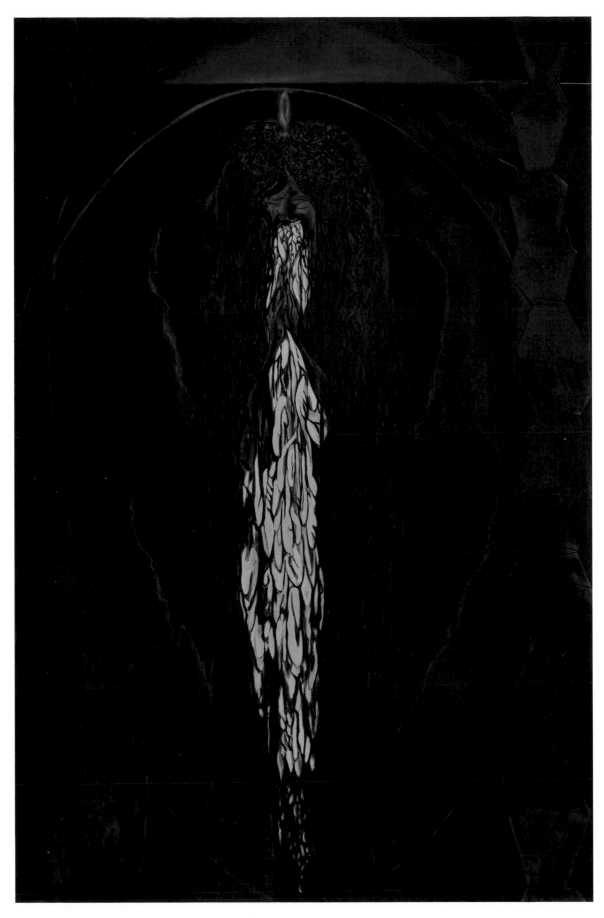

Walk this island. Feel it shudder under the weight of all the stories. It bucks and splutters and spits too. It vomits oil and pitch and volcanic mud. Feel the heat suck at your toes and understand why sometimes the people themselves, every twenty or so years, need to explode and purge themselves of their rotted politicians. Don't ever stop moving. The hot pitch might absorb you. Swallow your feet. Solidify around your ankles and leave you rooted there, stagnating your progress. This island is the medicine and the sickness too.

Meanwhile in the shadows of their skyscrapers, the children of forgotten gods confuse progress with trinkets.

Take this island as high science. Draw up equations to solve the mystery of how an island can make you love its ugliness so. How do these Gods walk past you in the market? Shiva opens a coconut and the universe spills its water at your feet. Jesus begs you to buy his king fish. Oshun sells you honey in a recycled rum bottle. They have forgotten that they are Gods because they too have fallen hopelessly in love with this place.

He dances for his children. For the children he has lost to other Gods. Gods who do not know the healing powers of plants. Gods who do not walk in the bush and speak the language of poisonous snakes.

Dance in the clearing where you saw them dance in your dreams. They watch you from the shadows, like they watch a young democracy on this old island. They watch and smile at how their dances are remembered in the Carnival. This freedom dance of death and loss and rebirth. Dance like devils and sailors and kings and ten thousand feathered bird women who have not yet learned to fly.

When you find him, will you know him? Will you weep when you look into his eyes?

Take this island as a sacrifice. There are many Gods to appease with the blood that flows freely. The roads are hungry for blood. Pray that it is not yours that will be spilt. The molten pitch has a taste for the flesh of young men. The young men have a taste for the blood of their women.

It is paradise lost. A paradise of loss. This is where you come to find yourself. This is where much has disappeared. Into the forest. Into canefields. Into drains choked with the carcasses of decimated trees. Where douens are now gangsters and the blood sucking soucouyant is your Member of Parliament.

If you call his name he may not answer. He appears only when you need him most.

Take this island now and put it in your pocket.

Like a tiny, bizarre trinket that you find on some North Coast beach. You wonder briefly where it has come from. How it reached this particular shore. What trials and tribulations have rubbed against it to give it this shape and this smooth shiny beauty. Hold it in your fingers, up to the sunlight. Keep it safe. Everything here is so very precious.

You will find him when you least expect it. Walking next to you. Dark and silent.

Among the lost things of this island find yourself whole again.

In paradise. New. In an old man's bag of medicine. In ancient words that you cannot understand. In moonlit bush kissed by the lips of rain swollen clouds. You are healed now. No money can pay for this medicine. No thanks can be said for a pain that slips quietly into the night. You wake sweating from your dreams. If that is what this place is. A dream of what could be. Of what is possible when Gods forget their way home. When they choose the market instead of heaven. When spirits dance like this piece of earth is a newborn star and the hills echo with the sounds of their drums and their laughter and the places in the earth already prepared for their footprints.

Dance in Shadow 2008–9
Oil on linen 280.7 x 196.3

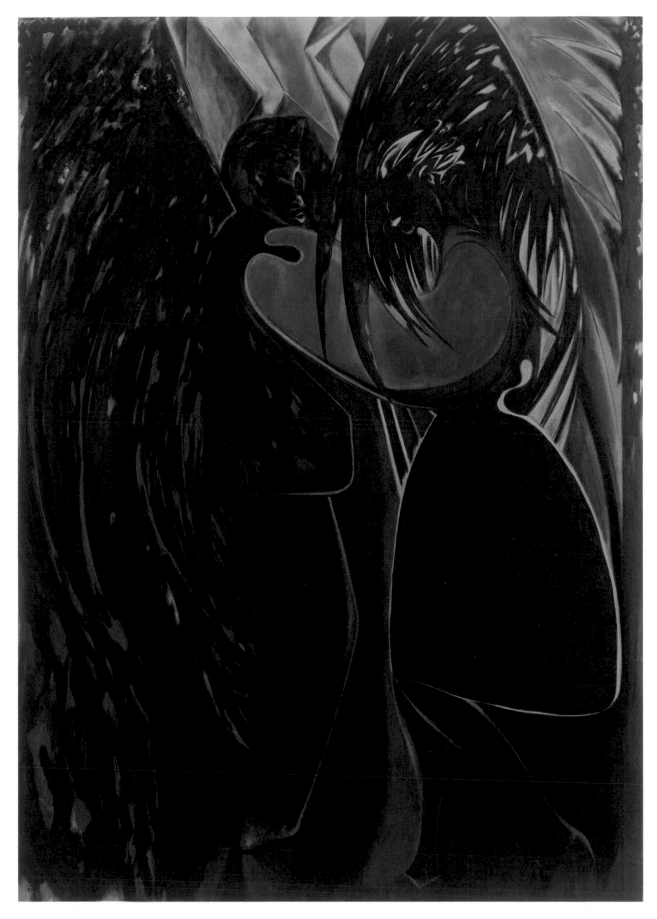

Last Light, First Flight 2008–9
Oil, charcoal, aluminium foil and paper
collage on linen 310.5 x 200.6

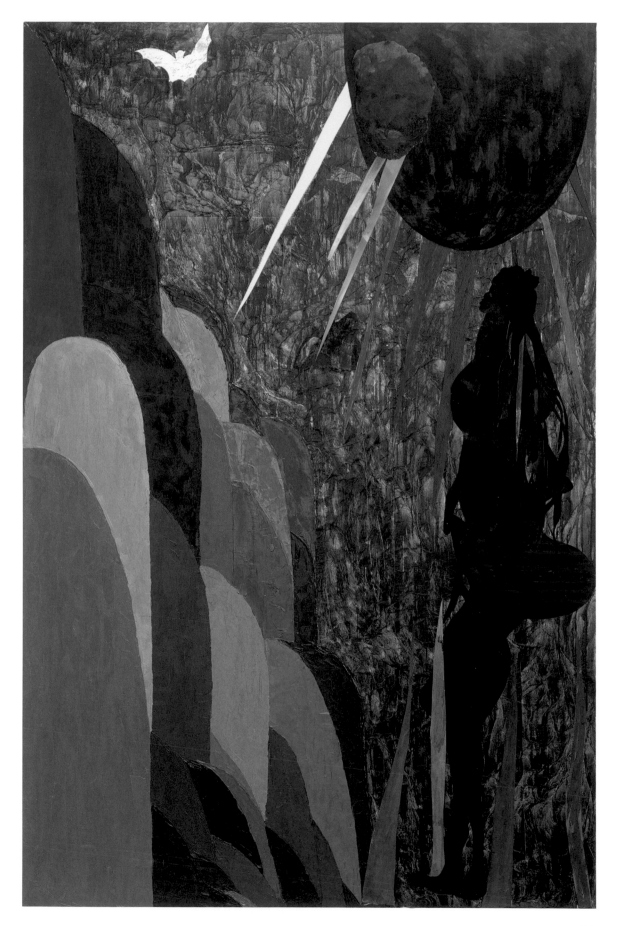

Death & the Roses 2009
Oil on linen 310.5 x 200.6

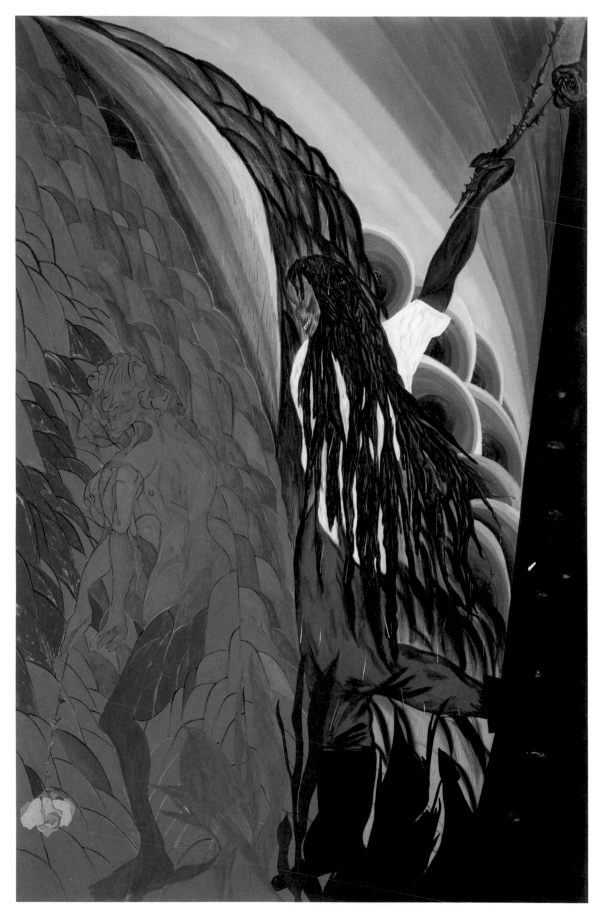

Habio Green Locks 2009
Oil on linen 310.5 x 200.6

FIG. 39
Self-Portrait (Orange Shirt) 1989
Oil on canvas 122.3 x 107.1

Chronology
Compiled by Helen Little

1968

Born in Manchester, United Kingdom

1980–5

Attends St Pius Roman Catholic High School in Longsight, Manchester

1985–7

Attends Xaverian Sixth Form College, Manchester

1987–8

Attends Tameside College of Technology, Ashton-under-Lyne, Lancashire (Foundation Course)

1988

Tomorrow's Artists Today, Smith's Gallery, London (group)

1988–91

Attends Chelsea School of Art, London (BA Fine Art)

1989

Awarded the Chelsea School of Art Christopher Head Drawing Scholarship

Prize-winner, **Whitworth Young Contemporaries**, Whitworth Art Gallery, Manchester, 3 November – 16 December (group)

1990

BP Portrait Award, National Portrait Gallery, London, 8 June – 2 September (group)

1991

BP Portrait Award, National Portrait Gallery, London, 7 June – 1 September (group)

Top Marks, London Institute Galleries, London, July (group)

Whitworth Young Contemporaries, Whitworth Art Gallery, Manchester, 8 November – 14 December (group)

Paintings and Drawings, Kepler Gallery, London (solo)

Blauer Montag, Raum für Kunst, Basel (group)

1991–3

Attends the Royal College of Art, London (MA Fine Art)

1992

Travels to Zimbabwe on a British Council scholarship to participate in the Pachipamwe International Artists' Workshop, organised by Triangle Arts Trust. The six-week visit has an immediate impact on his work. He sees the ancient cave paintings in the Matobo Hills, later recalling: 'I imagined them painting this great wall of optical, shimmering dots to the rhythm of chants and drumbeats, all of which got condensed into each dot.' (Interview with Adrian Searle, 'Going through the motions', in **Independent**, 27 December 1994.)

Attends Hochschule der Künste, Berlin on an Erasmus Exchange.

1993

Moves to a studio in Fulham, London.

Inspired by David Hammons' **Bliz-aard Ball Sale** (1983), Ofili organises an impromptu **Shit Sale** on Strasse 17 Juni, Berlin, where he sells elephant dung from a stall. A second **Shit Sale** takes place at London's Brick Lane market. 'I laid down a cloth with seven to ten pieces of dung on it, and put a sign out that said "ELEPHANT SHIT"… I was just showing them, like a museum would.' (From an interview with Marcelo Spinelli, in **Brilliant! New Art from London**, Walker Arts Center, Minneapolis 1995)

Makes three **Shithead** sculptures, each created from a ball of elephant dung adorned with the artist's hair, one with a set of milk teeth. Makes the series of works **Shit Joint**, formed of elephant dung rolled within Rizla cigarette papers.

Places stickers around London on fences, buildings and hoardings and takes out a quarter-page advertisement in **frieze** magazine (no.10, May 1993) which simply reads 'ELEPHANT SHIT'. 'When you flick through the advert pages and you see these big names – Richard Long, Brice Marden, duh, duh, duh. These big names kind of popping out at you … It looks good and I'd like to see Chris Ofili on the page, but I also just wanted to say "ELEPHANT SHIT". So I placed an ad that just said "ELEPHANT SHIT".' (Quote from Coco Fusco, 'Captain Shit and Other Allegories of Black Stardom', in **Nka Journal of African Art**, no.45, Spring/Summer 1999.)

Borderless Print, Rochdale Art Gallery, London, 26 March – 22 May (group)

Lift, Atlantis Basement, London (group). Ofili shows the first paintings to be propped on the floor with elephant dung.

To Boldly Go, Cubitt Gallery, London, 13 – 30 May (group). Stuart Morgan, critic and curator, invites three young painters, Jason Brooks, Laura Daly, and Chris Ofili, to make paintings for the exhibition with a two week deadline.

Riverside Open, Riverside Gallery, London, summer (group)

Painting School Degree Show, Royal College of Art, London, 2 – 12 June (group)

BT New Contemporaries, Cornerhouse, Manchester, 19 June – 1 August (group). Tours to Orchard Gallery, Derry; The Mappin Art Gallery, Sheffield; City Museum and Art Gallery, Stoke-on-Trent and Centre for Contemporary Arts, Glasgow

International Print Exhibition Machida-Tokyo, Machida City Museum of Graphic Arts, Tokyo, 10 October – 28 November (group)

Second Prize Winner, **Tokyo Print Biennale**, Tokyo (group)

1994

In a profile article in **frieze** magazine, Stuart Morgan writes that Ofili's work is 'caught between the Black arts movement in Britain – urging the return to African roots – and the multi-culturalism of borderline positions … Ofili has devised his own Dada commentary on his activities in order to explain his anomalous position, to himself as well as to his viewers.' (Stuart Morgan, 'The Elephant Man', in **frieze**, no.15, March – April 1994, p.43.)

Miniatures, The Agency, London, September (group)

Take Five, Anthony Wilkinson Fine Art, Henrietta House, London, November (group)

Painting Show, Victoria Miro Gallery, London, 22 November – 13 January (group)

1995

Paints the first **Afromuses**: small watercolour portraits of individuals, couples and groups, a continuing series over the next decade, characterised by a 'rhythmic, fluid and unbridled sense of colour'. (Thelma Golden (ed.), **Afro Muses**, exh. cat., The Studio Museum in Harlem, New York 2005.)

The artist spends time in Tate's print room making drawings and sketches of William Blake's watercolours **Satan in his Original Glory: 'Thou was Perfect till Iniquity was Found in Thee'** c.1805, and **The Four and Twenty Elders Casting their Crowns before the Divine Throne** c.1803–5, both in the Tate collection. Paints **Satan** and **7 Bitches Tossing their Pussies Before the Divine Dung** in response.

Popcorn is the first painting to incorporate cut outs from magazines.

In an interview with Marcelo Spinelli, Ofili comments that the black artist is fated to be seen as 'the Voodoo king, the Voodoo Queen, the witch doctor, the drug dealer, the Magicien de la Terre, the exotic.' (Chris Ofili interviewed by Marcelo Spinelli, London, 23 March 1995, excerpted in **Brilliant! New Art from London**, Walker Art Center, Minneapolis 1995, p.67.)

A Bonnie Situation, Contemporary Fine Arts, Berlin, 18 February – 25 March (group)

Selections Spring '95, The Drawing Center, New York, 16 March – 8 April (group)

Contained, Cultural Instructions, London, 6 April – 13 May (group)

Im/Pure, Osterwalder's Art Office, Hamburg, 20 May – 24 June (group)

19th John Moores Liverpool Exhibition of Contemporary Painting, Walker Art Gallery, Liverpool, 20 October 1995 – 28 January 1996 (group)

Brilliant! New Art From London, Walker Art Center, Minneapolis, 22 October 1995 – 7 January 1996, and Contemporary Arts Museum, Houston, 17 February – 14 April 1996 (group). Includes work by Glenn Brown, Jake and Dinos Chapman, Adam Chodzko, Mat Collishaw, Angus Fairhurst, Anya Gallaccio, Damien Hirst, Gary Hume, Abigail Lane, Sarah Lucas and Steven Pippin, Georgina Starr, Sam Taylor-Wood and Rachel Whiteread.

The British Art Show 4, Manchester, 12 November 1995 – 4 February 1996; Edinburgh, 24 February – 28 April 1996 and Cardiff, 18 May – 21 June 1996 (group)

Cocaine Orgasm, BANKSPACE, London, November – December (group)

Chris Ofili, Gavin Brown's enterprise, New York, 21 November 1995 – 6 January 1996 (solo)

2000

Appointed Trustee of Tate Gallery, London.

Makes first visit to Trinidad, invited by Caribbean Contemporary Arts to participate in an artist residency in Port of Spain.

Ant Noises 1, The Saatchi Gallery, London, 20 April – 20 August (group)

Raw, Victoria Miro Gallery, London, 7 May – 30 June (group)

Chris Ofili Drawings, Victoria Miro Gallery, London, 9 May – 23 June (solo)

12th Sydney Biennale, Museum of Contemporary Art, Sydney, 26 May – 30 July (group)

Of the Moment: Contemporary Art from the Permanent Collection, San Francisco Museum of Modern Art, 30 June – 29 August (group)

Nurture & Desire, Southbank Centre, London, 8 – 28 December (group)

2001

Appointed a sele
BT New Contem

Painting at the
Walker Art Cent
10 February – 6

Chris Ofili Wate
Tokyo, 9 March –

The Beauty of I
Gemeentemuse
10 February – 15
Kunsthalle, Bad
am Waldsee, Be

Public Offering
Contemporary /
1 April – 29 July

Works On Pape
Victoria Miro G
26 June – 15 Se

Form Follows
Museo d'Arte C
17 October 2001

One Planet un
Hip Hop and C
The Bronx Mus
26 October 200
to Walker Arts
and Spelman M
Atlanta (group)

The Mystery o
Sammlung Goe
29 October 200

1996

Moves studio from Fulham to Cubitt Studios in King's Cross. Ofili credits this area and its inhabitants of pimps, drug dealers and prostitutes as the inspiration for five paintings: **Blossom** (1997); **She** (1997); **Foxy Roxy** (1997); **Rodin … The Thinker** (1997–8) and **Pimpin' ain't easy** (1997). 'I wouldn't have done it if I didn't work in King's Cross. Those works came out of being here … It was just being here and seeing what was going on in the streets.' (Quoted in Kodwo Eshun, 'Plug into Ofili', in **Chris Ofili,** exh. cat., Southampton City Art Gallery and Serpentine Gallery, London, 1998, p.87.)

Captain Shit and the Legend of the Black Stars is the first of Ofili's 'Captain Shit' series of paintings, modelled on the stars of Blaxploitation films and comic book heroes including Luke Cage, the first African American superhero to appear in Marvel comic books, and the musician Captain Sky.

Wins **Wingate Young Artist Award,** Art '96, Business Design Centre, Islington, London

Maps Elsewhere, Institute of International Visual Arts, London, 23 March – 28 April (group). Ofili exhibits a series of copper plate etchings entitled **The Visit,** documenting a series of journeys between London and Berlin.

NowHere, Louisiana Museum of Modern Art, Humblebaek, 15 May – 8 September (group)

Afrodizziac, Victoria Miro Gallery, London, 25 May – 21 June (solo)

Young British Artists, Roslyn Oxley 9 Gallery, Paddington, 27 July – 17 August (group)

Popoccultural, South London Gallery, London, 30 October – 27 November and Southampton City Gallery, Southampton, 17 January 1996 – 6 April 1997 (group). Curated by Cabinet Gallery, London, this exhibition brings together work by British and American artists including Simon Bill, Ellen Cantor, Chris Carter, John Cussans, Jeremy Deller, Jason Fox, Dan Graham, Paul McCarthy, Ranu Mukherjee, Paul Noble, Simon Periton, Cosey Fanni Tutti, and Jeffrey Vallance.

About Vision: New British Painting in the 1990s, Museum of Modern Art, Oxford, 10 November 1996 – 23 February 1997; Fruitmarket Gallery, Edinburgh, 12 April – 31 May 1997; Wolsey Art Gallery, Ipswich, 6 September – 19 October 1997; Laing Art Gallery, Newcastle-upon-Tyne, 1997 – 1998 (group)

Mothership Connection, Stedelijk Museum Bureau, Amsterdam, 21 December 1996 – 9 February 1997 (group). The exhibition explores the themes of the Black Audio Film Collective's film **The Mothership Connection,** broadcast in 1995. Ofili creates a large-scale wall painting for the exhibition, whilst the film is being screened in the gallery.

1997

Invited by Matthew Higgs to contribute to the ongoing 'Imprint 93' series of artist editions, Ofili produces **Black,** a small book containing reproductions of twelve newspaper cuttings from the Wandsworth Guardian newspaper, each detailing a local street crime, in which the assailant is described as being 'black'. 'The idea of putting this document together was to put forward an ambiguous document. It could be used as racist propaganda. This could have been produced by the British National Party. You work it out.' (Quoted in Kodwo Eshun, 'Plug into Ofili', in **Chris Ofili,** exh. cat., Southampton City Art Gallery and Serpentine Gallery, London, 1998, p.88.)

Belladonna, ICA, London, 24 January – 12 April (group)

Pure Fantasy: Inventive Painting of the 90s, Oriel Mostyn, Llandudno, 31 May – 22 July (group)

Package Holiday: New British Art in the Ophiuchus Collection, The Hydra Workshop, Hydra, Greece, 26 July – 30 September (group)

Pictura Britannica: Art From Britain, Museum of Contemporary Art, Sydney, 22 August – 30 November. Tours to Art Gallery of South Australia, Adelaide and City Gallery, Wellington, New Zealand (group)

Minor Sensation, Victoria Miro Gallery, London, 9 September – 17 October (group)

Sensation: Young British Artists from the Saatchi Collection, Royal Academy of Arts, London, 18 September – 28 December (group)

Dimensions Variable: New Works from the British Council Collection, Helsinki City Art Museum, Helsinki, 4 November 1997 – 18 January 1998. Tours to Stockholm Royal Academy of Free Arts, Stockholm; Soros Foundation, Kiev; Zacheta National Gallery of Art, Warsaw; Städtische Kunstsammlungen, Chemnitz; Prague National Gallery of Modern Art, Prague; Zagreb Union of Croatian Artists, Zagreb; Institute Mathildenhohe, Darmstadt; Contemporary Art Centre, Vilnius; Ludwig Museum, Budapest; Slovak National Gallery, Bratislava and National Theatre Galleries, Bucharest (group)

20th John Moores Liverpool Exhibition of Contemporary Painting, Walker Art Gallery, Liverpool, 7 November 1997 – 15 February 1998 (group)

Date with an artist, Northern Gallery for Contemporary Art, Sunderland, 21 November 1997 – 14 February 1998 (group). The six-part television series of the same name documents contemporary British artists creating works relating to the lives of their recipients. Ofili creates an elephant dung painting for an inmate at Wormwood Scrubs Prison. (**Brad Lochore meets Anya Hurlbert/Chris Ofili meets Anthony Ismond**, 1997, dir. Flavia Rittner and Janet Lee, 30 mins, a BBC/Arts Council England production.)

Pimpin ain't easy but it sure is fun, Contemporary Fine Arts, Berlin, 27 November – 12 December (solo). The title of the show is derived from American rapper Big Daddy Kane's 1989 track of the same name.

1998

Awarded the Tu[...] been nominated[...] exuberance, hum[...] richness of his p[...] of cultural refere[...] solo exhibition a[...] Gallery and in S[...] Academy, Londo[...] Tate Gallery, Lo[...]

Drawing Itself, [...] London, 19 Marc[...]

A to Z, The App[...] 2 April – 3 May [...]

Chris Ofili, Sou[...] Gallery, Southa[...] 31 May; Serpent[...] 30 September – [...] Whitworth Art [...] 27 November 19[...] 1999 (solo)

Heads will roll, [...] London, 14 Sept[...]

The Jerwood F[...] Prize, Jerwood [...] 22 September – [...]

Turner Prize, T[...] London, 28 Oct[...] 10 January 199[...]

**Sensation: You[...] from the Saatc[...] to Hamburger [...] 30 September 1[...] 1999 (group)

Exhibited works

Measurements are given in cm,
height before width

Painting with Shit on it 1993
Oil, polyester resin, pigment
and elephant dung on canvas
182.8 x 121.9
British Council
(p.24)

Shithead 1993
Human teeth, artist's hair, polyester
resin and copper wire on elephant dung
11.5 x 18.5 x 18.5
Private collection
(p.23)

Afromuses (Couple) 1995–2005
Watercolour and pencil on paper
Diptych, each 24.3 x 15.7
Private collection
(p.58)

Afromuses (Couple) 1995–2005
Watercolour and pencil on paper
Diptych, each 24.3 x 15.7
Private collection
(p.58)

Afromuses (Couple) 1995–2005
Watercolour and pencil on paper
Diptych, each 24.3 x 15.7
Private collection
(p.58)

Afromuses (Couple) 1995–2005
Watercolour and pencil on paper
Diptych, each 24.3 x 15.7
Private collection
(p.58)

Afromuses (Couple) 1995–2005
Watercolour and pencil on paper
Diptych, each 24.3 x 15.7
Private collection
(p.58)

Afromuses (Couple) 1995–2005
Watercolour and pencil on paper
Diptych, each 24.3 x 15.7
Private collection
(p.58)

Afromuses (Couple) 1995–2005
Watercolour and pencil on paper
Diptych, each 24.3 x 15.7
Private collection
(p.70)

Afromuses (Couple) 1995–2005
Watercolour and pencil on paper
Diptych, each 24.3 x 15.7
Private collection
(not illustrated)

Afromuses (Couple) 1995–2005
Watercolour and pencil on paper
Diptych, each 24.3 x 15.7
Private collection
(not illustrated)

Blind Popcorn 1995
Acrylic, oil, polyester resin, paper
collage, glitter, map pins and
elephant dung on linen
182.8 x 121.9
Wilkinson Vintners Collection, London
(p.26)

**7 Bitches Tossing their Pussies Before
the Divine Dung** 1995
Oil, polyester resin, paper collage, glitter,
map pins and elephant dung on linen
182.8 x 121.9
James Moores Collection
(p.25)

Popcorn Tits 1995
Acrylic, oil, polyester resin, paper
collage, glitter, map pins and
elephant dung on canvas
182.8 x 121.9
Collection of Frank Gallipoli
(p.27)

Spaceshit 1995
Acrylic, oil, polyester resin, map
pins and elephant dung on linen
182.8 x 121.9
Collection Janet de Botton
and Rebecca Marks
(p.28)

Afro Daze 1996
Pencil on paper
56 x 76
Private collection
(p.55)

Afrodizzia (Second version) 1996
Acrylic, oil, polyester resin, paper
collage, glitter, map pins and
elephant dung on linen
243.8 x 182.8
Collection of Victoria and
Warren Miro, London
(p.31)

The Holy Virgin Mary 1996
Acrylic, oil, polyester resin, paper
collage, glitter, map pins and
elephant dung on linen
243.8 x 182.8
Museum of Old and New Art (MONA),
Hobart, Australia
(p.33)

Afrovoid (London 18.4.97) 1997
Pencil on paper
56 x 76
Sindika Dokolo – Colecção Africana
de Arte Contemporânea
(p.54)

Blossom 1997
Oil, polyester resin, glitter, map
pins and elephant dung on linen
243.8 x 182.8
Ole Faarup Collection, Copenhagen
(p.35)

Foxy Roxy 1997
Acrylic, oil, polyester resin, paper collage,
glitter, map pins and elephant dung on linen
243.8 x 182.8
Mitzi and Warren Eisenberg
(p.37)

Pimpin' ain't easy 1997
Oil, polyester resin, paper collage, glitter,
map pins and elephant dung on linen
243.8 x 182.8
Courtesy the Dakis Joannou Collection
(p.39)

She 1997
Acrylic, oil, polyester resin, paper
collage, glitter, map pins and
elephant dung on linen
243.8 x 182.8
Mima and Cesar Reyes Collection,
Puerto Rico
(p.41)

Two Doo Voodoo 1997
Acrylic, oil, polyester resin, paper
collage, glitter, map pins and
elephant dung on linen
243.8 x 182.2
Southampton City Art Gallery
(p.43)

No Woman, No Cry 1998
Acrylic, oil, polyester resin, pencil,
paper collage, glitter, map pins
and elephant dung on linen
243.8 x 182.8
Tate. Purchased 1999
(p.45)

**The Adoration of Captain Shit and
the Legend of the Black Stars** 1998
Oil, acrylic, polyester resin, paper
collage, glitter, map pins and
elephant dung on linen
243.8 x 182.8
Courtesy the Dakis Joannou Collection
(p.47)

Selection of twelve from thirty
Untitled 1998
Watercolour and pencil on paper
Each 24 x 15
Tate. Presented by Victoria Miro
and the artist 1999
(p.79)

Albinos & Bros with Fros 1999
Pencil on paper
56 x 76
Collection of Melva Bucksbaum
and Raymond Learsy
(pp.56–7)

Prince amongst Thieves 1999
Acrylic, oil, paper collage, glitter,
polyester resin, map pins and
elephant dung on linen
243.8 x 182.8
The Museum of Modern Art, New York.
Mimi and Peter Haas Fund, 1999
(p.51)

Third Eye Vision 1999
Oil, acrylic, paper collage, glitter,
polyester resin, map pins and
elephant dung on linen
243.8 x 182.8
Collection Walker Art Center, Minneapolis
T.B. Acquisition Fund, 2000
(p.49)

The Upper Room 1999–2002
Installation of thirteen paintings:

Mono Oro 1999–2002
Oil, acrylic, ink, gold leaf, polyester
resin, glitter, map pins and elephant
dung on linen
243.8 x 182.8
Mono Morado 1999–2002
Oil, pencil, polyester resin, glitter,
map pins and elephant dung on linen
182.8 x 121.9
Mono Blanco 1999–2002
Oil, acrylic, pencil, polyester resin, glitter,
map pins and elephant dung on linen
182.8 x 121.9
Mono Rojo 1999–2002
Oil, ink, polyester resin, glitter,
map pins and elephant dung on linen
182.8 x 121.9
Mono Rosa 1999–2002
Oil, pencil, polyester resin, glitter,
map pins and elephant dung on linen
182.8 x 121.9
Mono Turquesa 1999–2002
Oil, acrylic, pencil, polyester resin, glitter,
map pins and elephant dung on linen
182.8 x 121.9
Mono Amarillo 1999–2002
Oil, ink, polyester resin, glitter,
map pins and elephant dung on linen
182.8 x 121.9
Mono Marron 1999–2002
Oil, ink, polyester resin, glitter,
map pins and elephant dung on linen
182.8 x 121.9
Mono Verde 1999–2002
Oil, ink, polyester resin, glitter,
map pins and elephant dung on linen
182.8 x 121.9
Mono Naranja 1999–2002
Oil, pencil, polyester resin, glitter,
map pins and elephant dung on linen
182.8 x 121.9
Mono Negro 1999–2002
Oil, pencil, polyester resin, glitter,
map pins and elephant dung on linen
182.8 x 121.9
Mono Azul 1999–2002
Oil, acrylic, ink, polyester resin, glitter,
map pins and elephant dung on linen
182.8 x 121.9

Mono Gris 1999–2002
Oil, acrylic, ink, polyester resin, glitter,
map pins and elephant dung on linen
182.8 x 121.9
Tate. Purchased with assistance
from Tate Members, The Art Fund
and private benefactors 2005
(pp.80–95)

Afro 2000
Pencil on paper
56 x 76
Tate. Presented by Victoria Miro Gallery
2000
(pp.52–3)

Triple Beam Dreamer 2001–2
Acrylic, oil, leaves, glitter, polyester resin,
map pins and elephant dung on linen
182.8 x 304.8
Collection of Eileen Harris Norton
(pp.106–7)

Afro Love and Unity 2002
Oil, acrylic, polyester resin, glitter, map
pins and elephant dung on linen
213.3 x 152.4
Private collection
(p.111)

Afro Sunrise 2002–3
Acrylic, oil, polyester resin, paper
collage, glitter, map pins and
elephant dung on canvas
275 x 366
Private collection
(pp.108–9)

7 brides for 7 bros
Seven works:
Adam 2004–6, **Benjamin** 2006,
Caleb 2006, **Daniel** 2006, **Ephraim** 2006,
Frank 2006, **Gideon** 2006
Pencil on paper
Each 76.2 x 57.2
Mitzi and Warren Eisenberg
(pp.112–18)

A Gardener 2005
Watercolour and pencil on paper
Nine parts, each 24.3 x 15.7
Collection of Eileen Harris Norton
(p.63)

Blue Riders 2006
Oil, acrylic and charcoal on linen
278.4 x 200.2
Sender Collection
(p.121)

Iscariot Blues 2006
Oil and charcoal on linen
281 x 194.9
Susan and Leonard Feinstein
(p.123)

Christmas Eve (Palms) 2007
Oil, pastel, charcoal, aluminium
foil and paper collage on linen
281 x 195.3
Private collection
(p.133)

Confession (Lady Chancellor) 2007
Oil on linen
281 x 195.3
Courtesy the Dakis Joannou Collection
(p.129)

The Raising of Lazarus 2007
Oil and charcoal on linen
278.7 x 200.4
Collection of David and Monica Zwirner
(p.131)

Untitled (Afronude) 2007
Watercolour and pencil on paper
63.2 x 43.5
Private collection
(p.59)

Untitled (Afronude) 2007
Watercolour and pencil on paper
63.2 x 43.5
Private collection
(p.60)

Untitled (Afronude) 2007
Watercolour and pencil on paper
63.2 x 43.5
Private collection
(p.61)

Strangers from Paradise 2007–8
Oil and charcoal on linen
280.3 x 195.5
Courtesy of the artist
(p.125)

The Healer 2008
Oil on linen
310.5 x 200.6
Private collection
(p.137)

Blue Stag (All Fours) 2008–9
Oil on linen
280.7 x 196.3
Private collection
(p.127)

Dance in Shadow 2008–9
Oil on linen
280.7 x 196.3
Courtesy of the artist
(p.141)

Last Light, First Flight 2008–9
Oil, charcoal, aluminium foil
and paper collage on linen
310.5 x 200.6
Courtesy of the artist
(p.143)

Death & the Roses 2009
Oil on linen
310.5 x 200.6
Courtesy of the artist
(p.145)

Habio Green Locks 2009
Oil on linen
310.5 x 200.6
Courtesy of the artist
(p.147)

Photographic credits

Supporting Tate

Tate relies on a large number of supporters – individuals, foundations, companies and public sector sources – to enable it to deliver its programme of activities, both on and off its gallery sites. This support is essential in order for Tate to acquire works of art for the Collection, run education, outreach and exhibition programmes, care for the Collection in storage and enable art to be displayed, both digitally and physically, inside and outside Tate. Your donation will make a real difference and enable others to enjoy Tate and its Collection both now and in the future. There are a variety of ways in which you can help support Tate and also benefit as a UK or US taxpayer. Please contact us at:

Development Office
Tate
Millbank
London SW1P 4RG

Tel: 020 7887 4900
Fax: 020 7887 8098

American Patrons of Tate
520 West 27, Unit 404
New York, NY 10001
USA

Tel: 001 212 643 2818
Fax: 001 212 643 1001

Donations, of whatever size, are gratefully received, either to support particular areas of interest, or to contribute to general activity costs.

Gifts of Shares

We can accept gifts of quoted share and securities. All gifts of shares to Tate are exempt from capital gains tax, and higher rate taxpayers enjoy additional tax efficiencies. For further information please contact the Development Office.

Gift Aid

Through Gift Aid you can increase the value of your donation to Tate as we are able to reclaim the tax on your gift. Gift Aid applies to gifts of any size, whether regular or a one-off gift. Higher rate taxpayers are also able to claim additional personal tax relief. Contact us for further information and to make a Gift Aid Declaration.

Legacies

A legacy to Tate may take the form of a residual share of an estate, a specific cash sum or item of property such as a work of art. Legacies to Tate are free of inheritance tax, and help to secure a strong future for the Collection and galleries. For further information please contact the Development Office.

Offers in lieu of tax

Inheritance Tax can be satisfied by transferring to the Government a work of art of outstanding importance. In this case the amount of tax is reduced, and it can be made a condition of the offer that the work of art is allocated to Tate. Please contact us for details.

Tate Members

Tate Members enjoy unlimited free admission throughout the year to all exhibitions at Tate, as well as a number of other benefits such as exclusive use of our Members' Rooms and a free annual subscription to *Tate Etc*. Whilst enjoying the exclusive privileges of membership, you are also helping secure Tate's position at the very heart of British and modern art. Your support actively contributes to new purchases of important art, ensuring that the Tate's Collection continues to be relevant and comprehensive, as well as funding projects in London, Liverpool and St Ives that increase access and understanding for everyone.

Tate Patrons

Tate Patrons share a strong enthusiasm for art and are committed to giving significant financial support to Tate on an annual basis. The Patrons support the acquisition of works across Tate's broad collecting remit, as well as other areas of Tate activity such as conservation, education and research. The scheme provides a forum for Patrons to share their interest in art and to exchange knowledge and information in an enjoyable environment. United States taxpayers who wish to receive full tax exempt status from the IRS under Section 501 (c) (3) are able to support the Patrons through the American Patrons of Tate. For more information on the scheme please contact the Patrons office.

Corporate Membership

Corporate Membership at Tate Modern, Tate Britain and Tate Liverpool offers companies opportunities for corporate entertaining and the chance for a wide variety of employee benefits. These include special private views, special access to paying exhibitions, out-of-hours visits and tours, invitations to VIP events and talks at members' offices.

Mrs Daniela Gareh
Mrs Joanna Gemes
Mr David Gill and Mr Francis Sultana
Mr Simon Gillespie
Mr Mark Glatman
Mr and Mrs Paul Goswell
Penelope Govett
Gavin Graham
Mrs Sandra Graham
Martyn Gregory
Sir Ronald Grierson
Mrs Kate Grimond
Richard and Odile Grogan
Miss Julie Grossman
Mr Nick Hackworth
Alex Haidas
Louise Hallett
Mrs Sue Hammerson, CBE
Samantha Hampshire
Jane Hay
Richard Hazlewood
Michael and Morven Heller
Mr Iain Henderson Russell
Mrs Alison Henry-Davies
Mr Nigel Mark Hobden
Mr Frank Hodgson
Robert Holden
James Holland-Hibbert
Lady Hollick
Mrs Susanna Hong Rodzynek
John Huntingford
Miss Eloise Isaac
Mr Haydn John
Mr Michael Johnson
Mr Chester Jones
Jay Jopling
Tracey Josephs
Andrew Kalman
Mr Cyril Karaoglan
Dr Martin Kenig
Mr David Ker
Mr and Mrs Simon Keswick
Ali Khadra
David Killick

Mr and Mrs Paolo Kind
Mr and Mrs James Kirkman
Brian and Lesley Knox
Helena Christina Knudsen
Ms Marijana Kolak
Mrs Caroline Koomen
Kowitz Trust
Mr Jimmy Lahoud
Steven Larcombe
Simon Lee
Zachary R Leonard
Mr Gerald Levin
Leonard Lewis
Anders and Ulla Ljungh
Mr Gilbert Lloyd
George Loudon
Mrs Siobhan Loughran Mareuse
Mark and Liza Loveday
Charlotte Lucas
Daniella Luxembourg Art
The Mactaggart Third Fund
Mr M J Margulies
Mr and Mrs Jonathan Marks
Marsh Christian Trust
Dr Rob Melville
Mr Michael Meynell
Mr Alfred Mignano
Victoria Miro
Jan Mol
Mrs Valerie Gladwin Montgomery
Mrs Roberta Moore Hobbis
Erin Morris
Houston Morris
Mrs William Morrison
Mr Stamatis Moskey
Paul and Alison Myners
Mr and The Hon Mrs Guy Naggar
Richard Nagy
Mrs Gwen Neumann
Ms Angela Nikolakopoulou
Mrs Annette Nygren
Jacqueline O'Leary
Alberto and Andrea Olimon
Julian Opie

Pilar Ordovás
Mr O'Sullivan
Desmond Page
Maureen Paley
Dominic Palfreyman
Michael Palin
Cornelia Pallavicini
Mrs Kathrine Palmer
Phyllis Papadavid
Stephen and Clare Pardy
Ms Camilla Paul
Mr Mauro Perucchetti
Eve Pilkington
Lauren Prakke
Oliver Prenn
Susan Provezer QC
Mrs Barbara Prideaux
Mr and Mrs Ryan Prince
Valerie Rademacher
Miss Sunny Rahbar
Mrs Phyllis Rapp
Mr and Mrs Philip Renaud
The Reuben Foundation
Sir Tim Rice
Lady Ritblat
Mr Bruce Ritchie and Mrs Shadi Ritchie
Tim Ritchie
Kimberley and Michael Robson-Ortiz
David Rocklin
Frankie Rossi
Mr James Roundell
Mrs Charles Roxburgh
Mr Alex Sainsbury and Ms Elinor Jansz
Mrs Sherine Sawiris
Cherrill and Ian Scheer
Sylvia Scheuer
The Schneer Foundation
Mr Andrew Scott
Ms Joy Victoria Seppala-Florence
Amir Shariat
Neville Shulman, CBE
Andreas B Siegfried
Andrew Silewicz
Ms Julia Simmonds
Mr and Mrs David T Smith